WALTHAMSTOW

THROUGH TIME

Lindsay Collier

AMBERLEY PUBLISHING

First published 2014

Amberley Publishing
The Hill, Stroud, Gloucestershire, GL5 4EP
www.amberley-books.com

Copyright © Lindsay Collier, 2014

The right of Lindsay Collier to be identified as the
Author of this work has been asserted in accordance with
the Copyrights, Designs and Patents Act 1988.

ISBN 978 1 4456 2179 1 (print)
ISBN 978 1 4456 2194 4 (ebook)

British Library Cataloguing in Publication Data.
A catalogue record for this book is available from the
British Library.

Typesetting by Amberley Publishing.
Printed in Great Britain.

Introduction

Most people today would associate Walthamstow with William Morris, its High Street, the pop band East 17, and its famous greyhound stadium called the 'Stow', now sadly closed. However, not many people also know that Walthamstow is the home of the first all-British aviation flight, made by Alliott Verdon Roe on Walthamstow Marshes in 1909, or the home of Britain's first motor car, constructed in 1892 by Fredrick Bremer, and the home of London's buses, built by the Associated Equipment Company. The B-type bus is just one of London's most famous buses, built by the company in 1910. Walthamstow has a great industrial heritage story, which will also be captured within this publication.

Walthamstow forms part of the London Borough of Waltham Forest, and originally spanned only 2½ miles from north to south. Noted in the mid-nineteenth century for its fine views and woodland, the town lies 6½ miles north-east of the City of London. Its urban jungle is relieved today by its green spaces, sports grounds, museums and large reservoirs. Walthamstow's northern border is shared with Chingford to the north and Woodford and Wanstead to the east. The long, straight southern boundary is shared with Leyton and Leytonstone to the south and east. The west boundary with Hackney, Tottenham and Edmonton followed the course of the River Lea, which also forms the county boundary between Essex and Middlesex.

Walthamstow became an urban sanitary district in 1873 and a municipal borough in 1929. It became a fully-fledged London borough in 1965 when it merged with Chingford and Leyton. The name Walthamstow derives from 'Wilcumestouue', which means 'the welcome place'. This was the name given to the area by the Saxons. It was later changed to 'Wilcumstow' when Waltheof, the Earl of Huntingdon and Northumbria, married Judith, the niece of William the Conqueror. Waltheof, having committed treason, was then executed and the land was then passed to the Toni family, who decided upon its present name of Walthamstow.

The recorded population in 1086 was eighty-two. During the 1890s, Walthamstow was rivalled in growth only by East Ham. By 1911, the population had reached 124,580, growing to 132,972 in 1931. However, numbers had begun to decline seven years later, and this trend continued after the Second World War, falling to 121,135 in 1951 and 108,845 in 1961. In 2007 the population was recorded at 220,000.

Walthamstow's roads were planned on a grid pattern, with three east–west routes intersected by three north–south routes. Today, the most important road bridges crossing the River Lea

are at the Tottenham border, at the Ferry Boat Inn, and at Lea Bridge with Hackney in Leyton. Before then, the only way to cross the River Lea was by ferry. In 1927–30, the North Circular Road (A406) was extended from Edmonton through Walthamstow to Woodford via the Crooked Billet and on to the Waterworks Corner, which today connects with the M11 motorway.

Seventeenth-century Walthamstow was mainly comprised of large houses with landscaped gardens, home to public officials and bankers from London. As the original village centre, St Mary's church at Church End was designated a Conservation Area in 1968. The majority of town planning was carried out by speculative land societies, who determined the pattern of growth. In 1912, the Warner Estate Company, owned by T. C. T. Warner, one of the largest landowners in Walthamstow, decided to work with the urban district council to move forward with their town planning scheme. Consequently, growth in the north and north-east of the town took place on a more informal basis than the earlier development to the south.

The coming of the railway to Lea Bridge in 1840 brought great changes to Walthamstow, with the common fields being broken up in 1850. In 1707, a stagecoach service was run by Walthamstow resident John Gibson, and from 1764 to 1870 stagecoaches were run into the city by Francis Wragg's company. Horse trams were also operated in Lea Bridge Road in the 1880s. The Walthamstow Urban District Council Light Railways operated a tramway service between 1905 and 1933. In 1909, two Latvian anarchists attacked a clerk in Tottenham and stole a large amount of money. During the subsequent police chase, several people lost their lives. The thieves then commandeered a tram in Chingford Road, Walthamstow, to get away. The money was never found, and one of the thieves later committed suicide. This incident became known as the 'Walthamstow Tram Chase'.

A branch railway line from Lea Bridge to Walthamstow was opened by the Great Eastern Railway in 1870. The Midland Railway's Tottenham and Forest Gate line, completed in 1894, had stations at Blackhorse Road and Walthamstow. The Victoria Underground line between Highbury & Islington and Walthamstow opened in 1968. The line was completed to Victoria in 1969, and was the first fully automated underground railway in the world.

Bombing during the Second World War had much impact on the appearance of Walthamstow, and the town was further transformed by a variety of municipal housing schemes constructed from the 1940s. Blocks of council flats began to mark the landscape in the late 1960s, and business centres, such as Hoe Street Central Parade, also underwent changes. Comprising shops, flats and a lecture hall, the Parade was constructed in 1958–64, along with a clock tower decorated with local coats of arms. In 1971, a modern shopping centre was also being developed in Wood Street. The old High Street shopping arcade has now gone, and is today being replaced by a new shopping centre, flats and a multiplex cinema. A new hotel is also currently being constructed near Walthamstow Central station.

I hope that by reading this publication it will encourage you to visit Walthamstow and research your local history, as you never know what you might discover!

Lindsay Collier MA, 2014

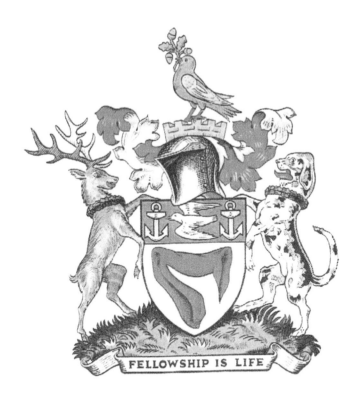

FELLOWSHIP IS LIFE

The Coat of Arms of the Municipal Borough of Walthamstow

Every aspect of the coat of arms has specific relevance to the history of Walthamstow. Upon the shield can be seen the arms of George Monoux, a wealthy citizen of the town in Tudor times. This is flanked by the stag and talbot of the Maynard family, known for their benefactions since the seventeenth century. Below this is a 'maunch', or sleeve, the insignia of the Toni family, dating back to Norman times. At the bottom of the shield is the legend, 'Fellowship is Life', a quote from one of Walthamstow's most famous residents, William Morris. The official description of the coat of arms reads as follows:

> *Arms:* Argent a Maunch Gules [red tincture] on a Chief Azure a Seamew volant between two Anchors Argent.
> *Crest:* Upon a Mural Crown Or a Dove Azure beaked and legged Gules winged Or holding in the beak a sprig of Oak fructed proper.
> *Supporters:* On the dexter [right] a Stag and on the sinister [left] side a Pie-Bald Talbot, each gorged with a Wreath of Oak all proper.
> *Legend:* 'Fellowship is Life'.

In 1965, the Municipal Borough of Walthamstow merged with Chingford and Leyton to form the London Borough of Waltham Forest, which has a different coat of arms.

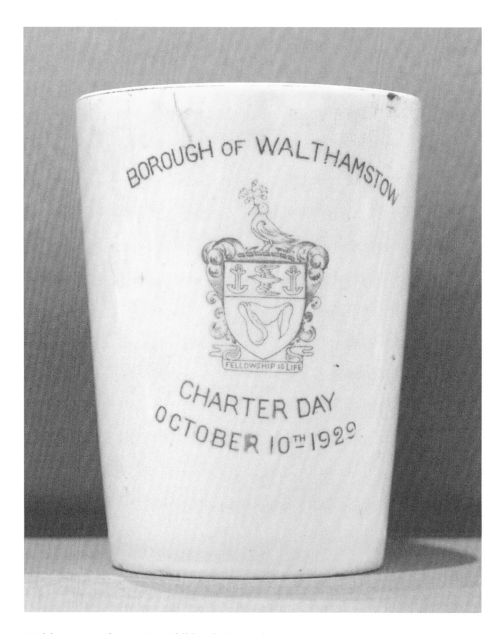

Walthamstow Charter Day Children's Souvenir Mug

The above souvenir beaker was presented to John Brett of Ardleigh Road, Walthamstow. Following various discussions relating to incorporation of the parish as a municipal borough over the years, a petition was finally submitted to the Privy Council in 1920. However, this was delayed by the Royal Commission on London Government, who accused the borough of improper conduct during the 1926 General Strike. Walthamstow was finally incorporated as a London borough three years later.

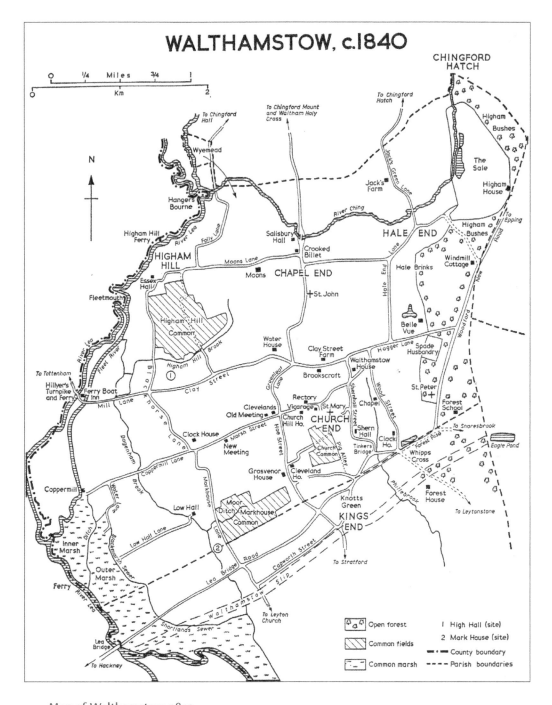

Map of Walthamstow, 1840

Originally part of the Becontree Hundred of Essex, Walthamstow was grouped into the West Ham Poor Law Union in 1837. As seen above, it was a largely rural area.

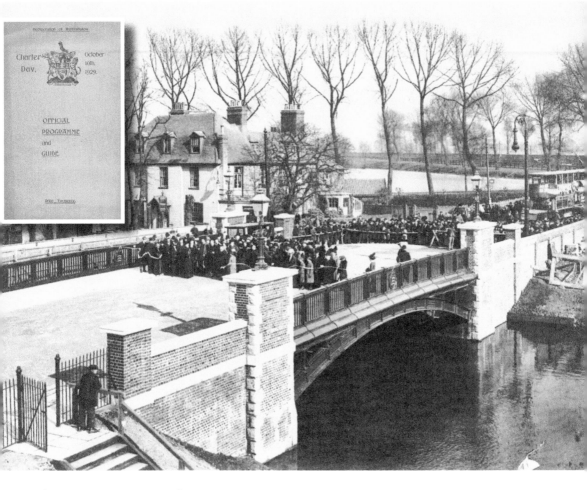

Charter Day Event, 10 October 1929

Over forty tramcars were used in a special procession, which started at the Old Town Hall in Orford Road at 10 a.m. It then continued by foot and tramcar from Hoe Street to Ferry Lane Bridge, which crosses over the River Lea. At 10.30 a.m. the dignitaries and guests all disembarked from their various tramcars and made their way to a marquee for the presentation of the charter document, the arrival of which was celebrated with a firework display. At 10.45 a.m. the charter document was then presented and extracts were read out. The procession then returned to the Town Hall where speeches were given and the National Anthem was sung. Toasts given were simultaneously broadcast to the recreation grounds in Selborne Road and Conway Hall. There was also a wreath-laying ceremony. The children of the borough also had their own procession, followed by refreshments and entertainment, after which they were each given a commemorative beaker. In the evening a grand fireworks display was held at the Chestnuts Farm in Forest Road. On Sunday 13 October, a civic service was held in the parish church of St Mary's. A picture of this event has not been found; however, a picture showing the opening of the Ferry Lane Bridge in 1917 is a good example of what the event in 1929 would have looked like.

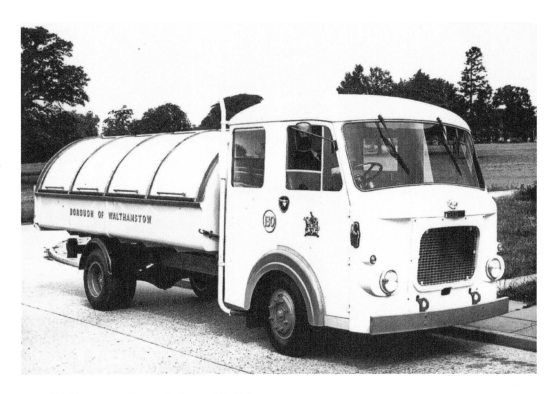

Walthamstow Borough Council Vehicles
Above is an early Dennis borough dustbin collection vehicle, and below a lighting repair truck.

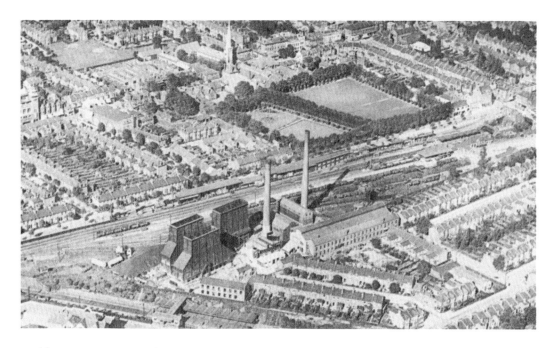

Walthamstow Power Station

The Municipal Borough of Walthamstow had its own power station, situated in Exeter Road. The station was opened on 20 September 1901. Power was initially generated by gas and then by steam in 1920. Over the years, the station provided Walthamstow with power for its electric street lighting, factories, tramway system, and even supplied power to other parts of the borough. From 1 April 1948, the station fell under the control of the British Electric Authority and its power was then distributed by the London Electricity Board. After nationalisation and the move towards larger generating stations and new sources of power, the station's contribution to the national grid system became uneconomic. The station was closed in March 1968 with a special ceremony, which was attended by the mayor, Cllr D. Wainstein, who shut down the station's last generator. The huge number of coal sidings situated in front of the power station became the location for a London & North Eastern Railway promotional railway exhibition in 1937. Today the station has all but gone, having been replaced by houses.

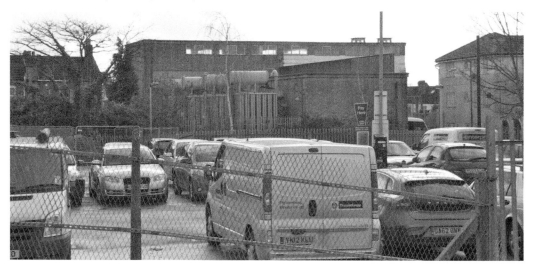

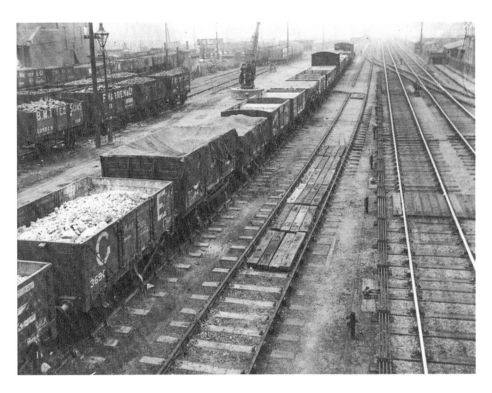

Hoe Street Station Goods Yard

A view of the Hoe Street coal sidings, showing the many different types of railway wagons in use at that time. Tracks serving a bay platform and a timber yard, now gone, can be seen at the top right of the picture. Houses now occupy the yard.

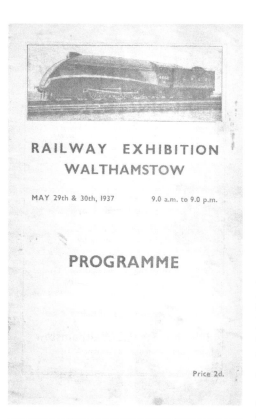

RAILWAY EXHIBITION
WALTHAMSTOW

MAY 29th & 30th, 1937 9.0 a.m. to 9.0 p.m.

PROGRAMME

Price 2d.

Walthamstow Railway Exhibition at Hoe Street Station Yard, 1937

This railway exhibition was one of the many promotional events held in London by the London & North Eastern Railway. Some of the proceeds of the event were given to the Walthamstow Connaught Hospital fund. The naming of a Footballer class locomotive also took place. The locomotive was named *Tottenham Hotspur,* and went on to be streamlined by the company. The nameplates and two special commemorative plaques that were attached to the locomotive are now on show at the Tottenham Hotspur football ground. Other famous locomotives also on display at the event included *Green Arrow, Silver Fox* and *Golden Eagle.* Many LNER carriages and wagons were also on display over the two days of this special exhibition, which was attended by many thousands of local people and enthusiasts.

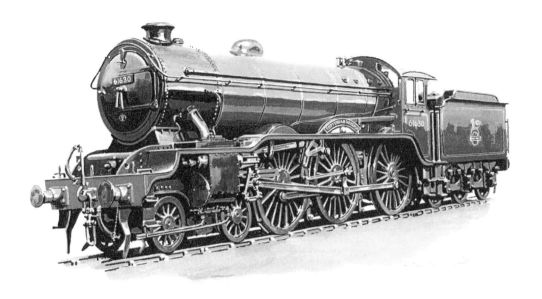

B12 Locomotive 61630 Tottenham Hotspur

The image above was painted by Jonathan Clay, and depicts LNER B12 class locomotive No. 61630 *Tottenham Hotspur*. This locomotive was named in 1937 at a London & North Eastern Railway exhibition held at Hoe Street Station. Below is a postcard celebrating the centenary of the Chingford Line in 1970. The image shown is of an N7 class steam locomotive, which was used on the line for many years before it was electrified.

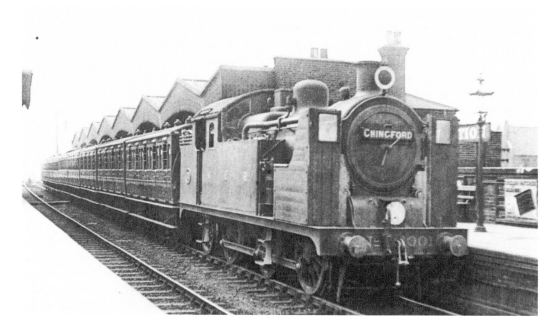

The Jazz Service Old and New on the Chingford Line

Above is an image of an early N7 class locomotive, No. 1001, standing at Bethnal Green station in East London. These were used heavily on the line for many years between Liverpool Street station and Chingford. The coaches behind are of the four-wheeled type, which were built at Stratford Railway Works. On the side at the top of these coaches would be painted stripes, either in light blue or yellow. This signified the different class of carriages, blue being second, and yellow first. In the 1930s, when jazz music was all the rage, the train sides were regarded as 'jazzy'. From then on, the train was known as the 'jazz train'. Below is a Great Eastern J69 class locomotive No. 87, which was used to work these trains before the more powerful N7 class locomotive took over.

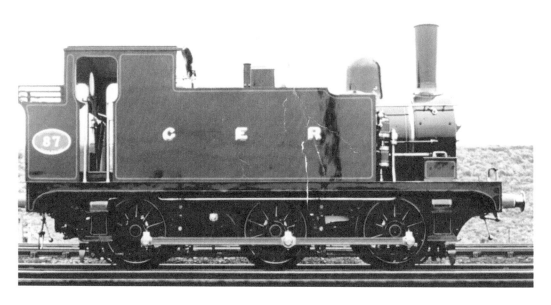

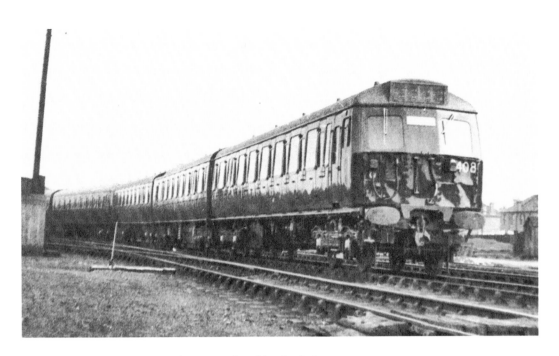

The Jazz Service Old and New on the Chingford Line

Above is an electric train, known as an electric multiple unit (EMU), which replaced the old steam locomotives and carriages on the Chingford Line in November 1960. Even with these new trains, the speed of the services did not dramatically increase. Below is a view of Liverpool Street station platforms No. 2 and No. 3 in the 1930s. The first four platforms at the station were mainly used for the Jazz Service trains to Chingford, Enfield and the Lea Valley. Around this time, the services out of Liverpool Street were referred to as the most intense surburban steam service in the world.

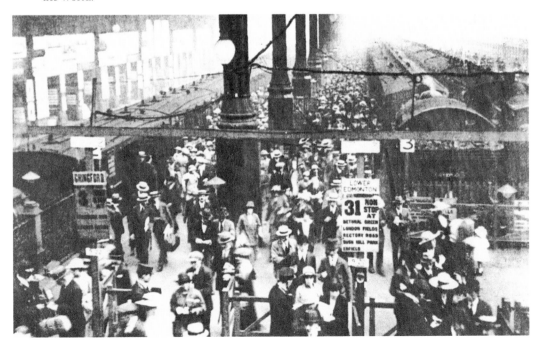

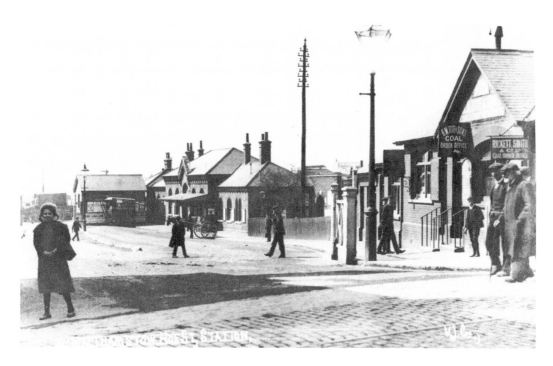

Walthamstow Central (Hoe Street Station)

Hoe Street station was opened in 1870 by the Great Eastern Railway, being renamed Walthamstow Central in 1968 when the London Underground service opened. Like many stations on the Victoria Line, the underground station was never completely finished. The mid-Victorian Up side building is remarkably well preserved, though the main entrance to Walthamstow Central is on the Down side. A subway entrance was completed in 2008, and a footpath leading to Walthamstow Queen's Road was scheduled for completion in 2013. Today, the old station entrance is very much still a building site.

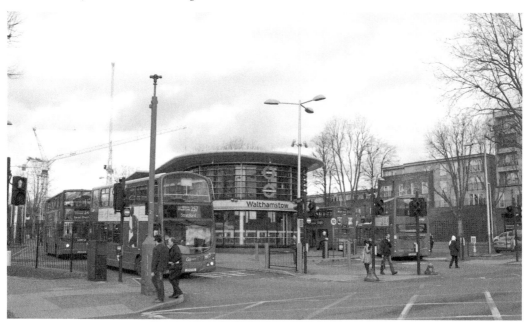

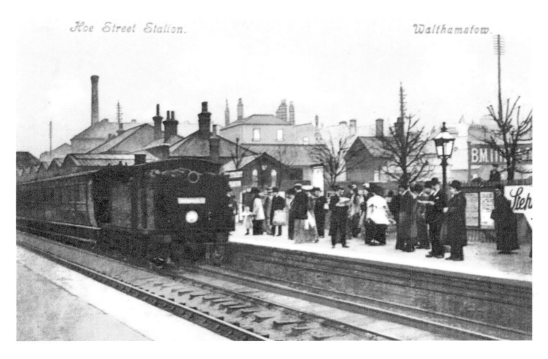

Walthamstow Central (Hoe Street Station)

Above is an old postcard showing a busy platform. Below is a modern view showing the platforms and the line's rolling stock as it is today.

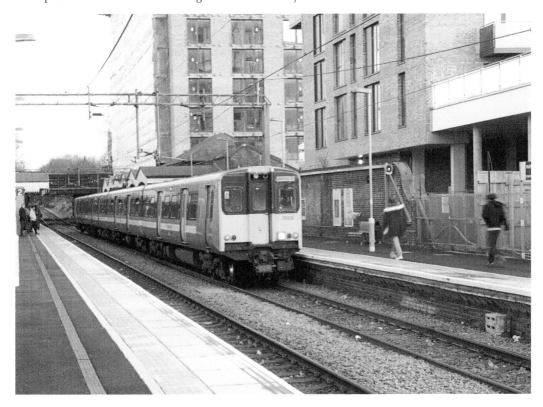

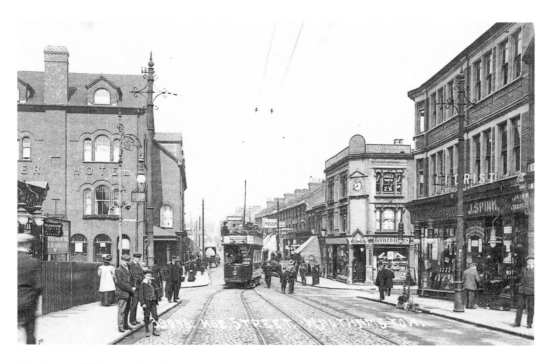

Hoe Street Old Tower Hotel, *c.* 1900

Today, the building above is called the Goose, formerly the Goose and Granite. Originally known as the Tower Hotel, it was subsequently renamed Flanagan's Tower, and eventually Flanagan's. Our view from the station's railway bridge shows part of the hotel to the left of the picture, with another Walthamstow Corporation tramcar on the right.

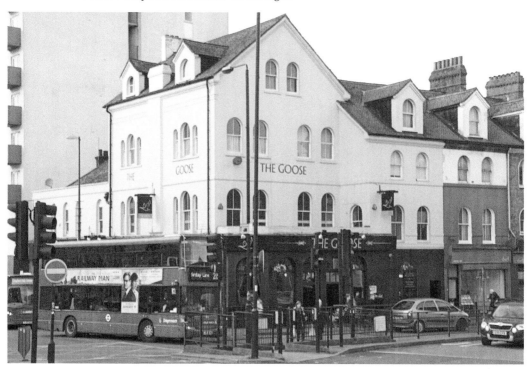

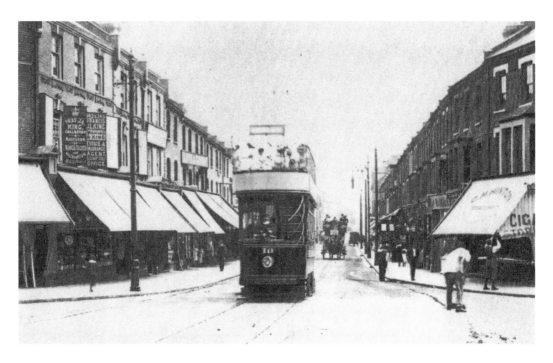

Hoe Street from the High Street End

The view shown above is now completely different from the one shown below, which is made up of many takeaway cafés and estate agents. We are treated to another Walthamstow Corporation tramcar No. 10 in the centre of the picture, with a horse bus following behind. As most of the shops shown have their blinds pulled down, we can presume that this picture was taken on a hot summer's day.

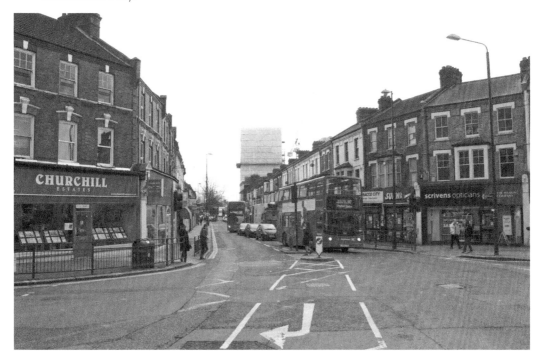

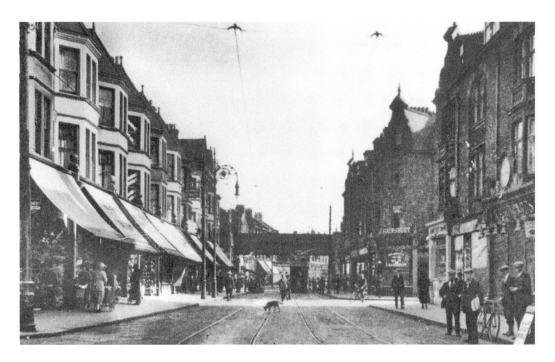

St James Street, *c.* 1914 and Today

St James Street is situated at the southern end of Walthamstow High Street. Crossing over St James Street you will come to Coppermill Lane, which has a historic industrial mill at the bottom of it. The history of this will be covered later in this publication. At the junction of these two streets once stood a Woolworths and a Burtons Menswear shop, which is now a charity shop. In the above photograph, towards the station on the right you will find a Sainsbury's store, and just past the railway bridge was a London Co-operative store (not shown in the picture). What a different type of view we have today 100 years later!

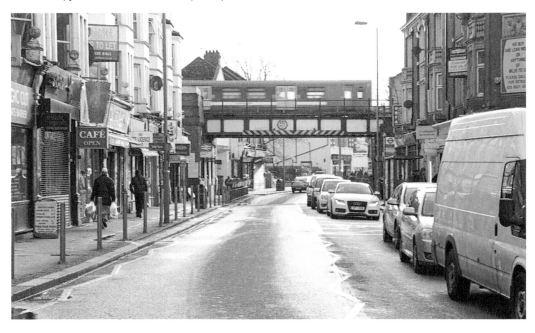

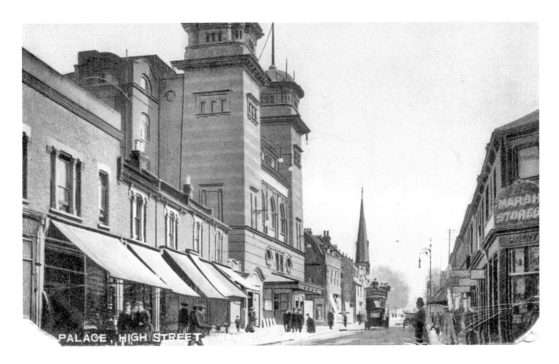

Walthamstow High Street Showing the Palace Theatre (*above*) **and the Market Today** (*below*)
High Street, which was once called Marsh Street, runs from Hoe Street in the north to St James Street in the south. Like many of the borough's past landmarks, the Palace Theatre has now gone. Dating from 1885, the Walthamstow High Street market is the longest outdoor street market in Europe. It has been stated that this landmark can even be seen from outer space! Visitors to the market can find food ranging from pie and mash to Caribbean dishes, with stalls also selling a variety of household goods and clothes.

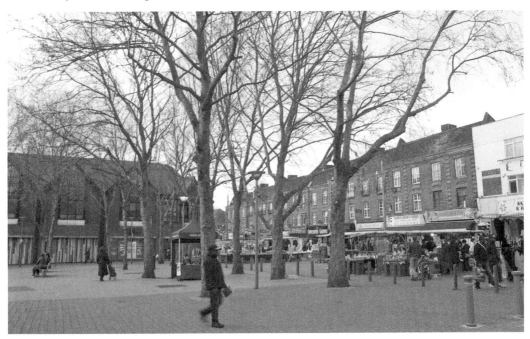

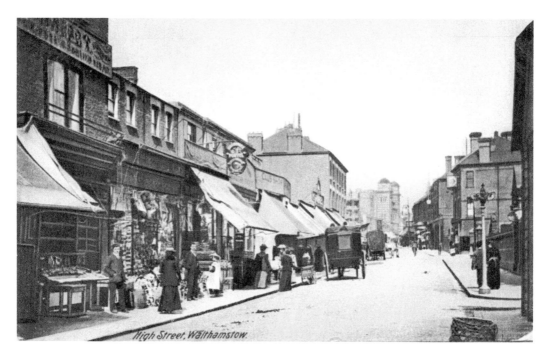

Old Postcard View of Walthamstow High Street and as it is Today

Another view of the High Street further down from the Palace Theatre, showing some of the many different types of shops then. In the nineteenth century, Marsh Street, as it was known then, started as a rural lane, which was transformed into the High Street by the town's Victorian expansion and the coming of the railway. Today it is the centre of Walthamstow, with most of the commercial development and activity located around it. Note the difference in the style of today's shopfronts below.

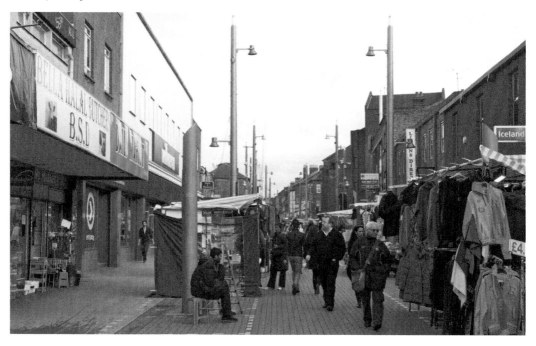

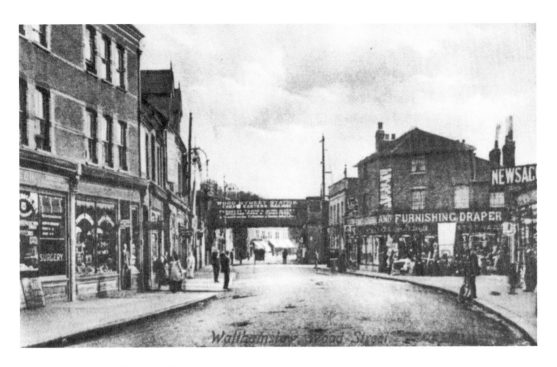

Wood Street Past and Present

Above is Wood Street shopping centre, shown as it was in the 1870s when the Great Eastern Railway opened its station there. It was one of the four settlements that formed the parish of Walthamstow. Most of the area surrounding Wood Street in the past was farmland. It was later converted for dairy production and market gardening. Speculative builders started to construct a series of two-storey houses off Wood Street, which was soon joined with Walthamstow Village, once the heart of Walthamstow. Today, Wood Street also has a thriving indoor market, located in the pink building on the right of the photograph below.

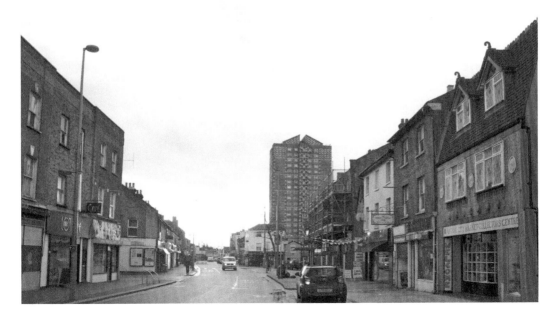

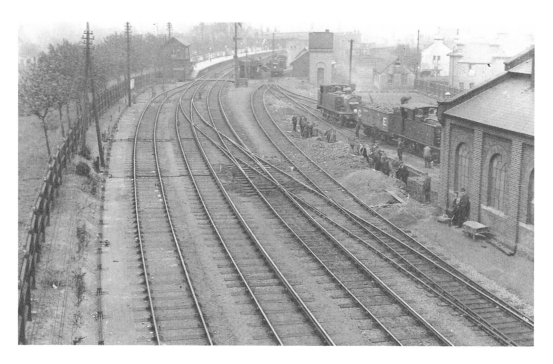

The Wood Street Great Eastern Railway Engine Shed and Station

The engine shed to the right of the picture above was constructed in 1878 to house the locomotives used on GER services from Chingford to Liverpool Street. A number of carriage sidings were located either side of the tracks. Wood Street was a sub-shed of Stratford, and was eventually closed upon the electrification of the line in 1960. Plans had been made to extend the Victoria Line from Walthamstow Central to Wood Street, where the line would terminate next to the British Railway station. Now used as a garden centre, the goods depot closed in 1968.

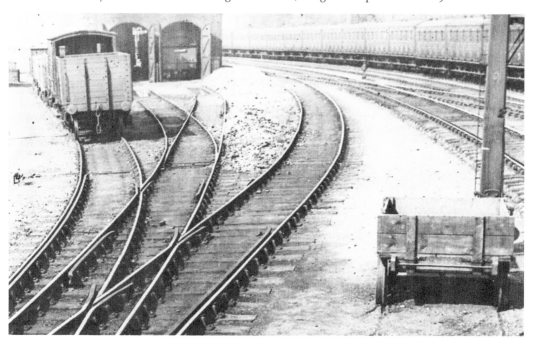

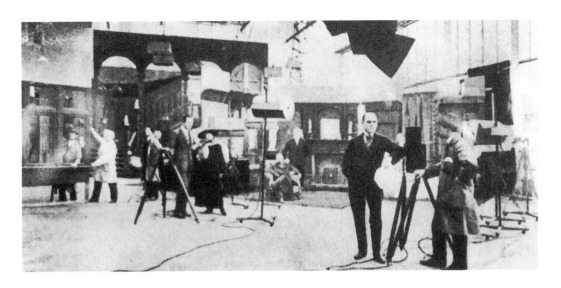

Walthamstow's Film Industry

Walthamstow had a number of early film studios, despite being an unusual location for the production of motion pictures. The first was the Precision Studio at Whipps Cross in 1910, which closed in 1915. The next studio, the British & Colonial Kinematograph Co., converted an old roller skating ring into a studio in Hoe Street. The company employed such actors as Jack Buchanan and Lilian Braithwaite, and produced such famous films as *When London Sleeps* (1914) and *The Battle of the Somme* (1916) before being dissolved in 1924. Back in Wood Street, the Cunard Film Company Limited operated a studio from 1913–16. Among its stars were Gladys Cooper and Owen Nares. Its most famous production was *The Call of the Drum* (1914). The studios became the home of the Broadwest Film Company the following year, who specialised in filming novels and stage plays until the studios again closed in 1924 when the company went bankrupt. Filmcraft Limited were the next owners, producing a series of films on Dick Turpin. Being close to Epping Forest, this was an ideal location for such productions. Two more companies then tried their luck. They were the Metropolitan Films Ltd until 1931 and the Audible Filmcraft Ltd in 1932. By 1933, the Wood Street studio was a factory, which was destroyed by a fire in 1959, ending the borough's brief competition with Hollywood.

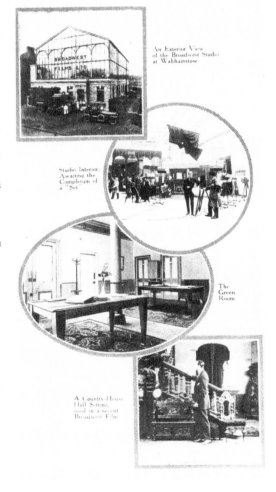

An Exterior View of the Broadwest Studio at Walthamstow

Studio Interior, Awaiting the Completion of a "Set"

The Green Room

A Country-House Hall Setting, used in a recent Broadwest Film

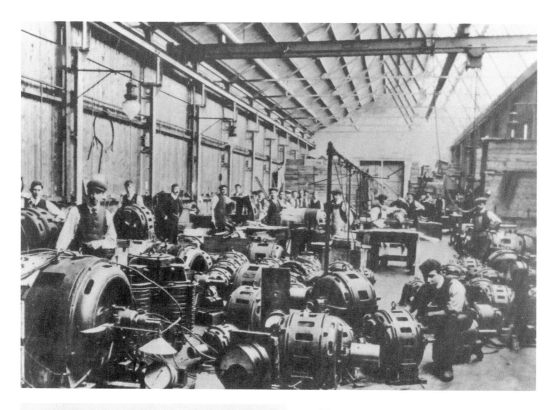

Walthamstow Industries: Fullers, ASEA, and Hawker Siddeley

In 1905, the Fuller-Wenstrom Electrical Manufacturing Company, who built and distributed Swedish-made electric motors, relocated from West London to Blackhorse Lane, Walthamstow. The following year, the company became known as Fuller Electrical and Manufacturing Company, and in 1910 the Allmänna Svenska Electric Co. Ltd was created, later to become ASEA (Great Britain) Ltd. Both companies operated from a factory on Fulbourne Road, and began to manufacture transformers there in 1919. The factory was enlarged a number of times but was damaged during air raids in 1944 and replaced by a factory on the other side of the same road. This factory was formerly the premises of Barnet Ensign Ross, and was acquired and renamed the West Works in 1955.

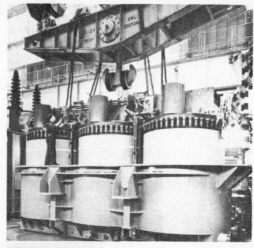

consult—

FULLER
ELECTRIC

Our Works is equipped to build transformers up to the largest sizes and highest voltages in use anywhere in the World. Our manufactures include also : On-load Tap changers. Variable speed A.C. Commutator Motors. Specialized equipment for the graphic industry. Electric Power Track. Special welding electrodes.

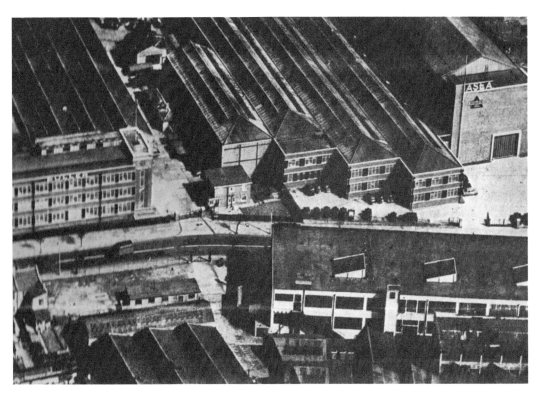

Walthamstow Industries: Fullers, ASEA, and Hawker Siddeley

At Poplar, Leyton and Birmingham, other factories were closed and all work was relocated to Walthamstow. Fuller Electric was acquired by the Brush Group in 1957, who later merged with Hawker Siddeley. The company was granted permission by ASEA to continue building motors and transformers to the Swedish design. In 2003, the company closed. A new school called the Frederick Bremer Academy now occupies the site, which was named after the inventor of the first British car, constructed in Walthamstow in 1892.

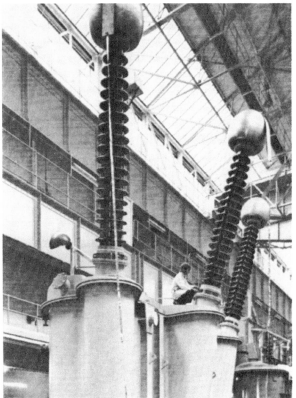

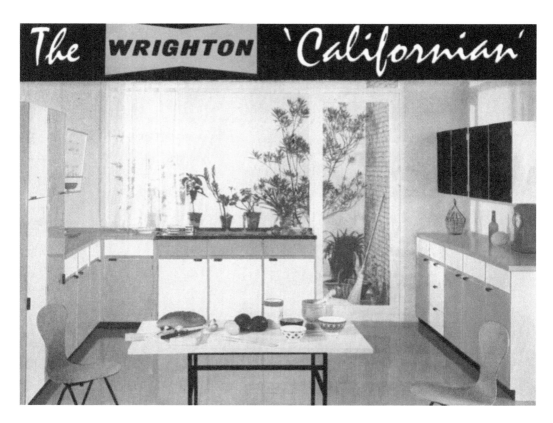

The WRIGHTON 'Californian'

F. Wrighton & Sons Furniture and Mosquito Aircraft Builders

F. Wrighton & Sons, who made high-class furniture, started in Hackney in 1923 but moved to a new 6-acre factory site in Billet Road, Walthamstow in 1933, called the Brampton Works. During the Second World War, they ceased to make furniture and started to make bodies for the first all-wooden fighter aircraft, the Mosquito. Over 1,000 were made, as the picture below shows.

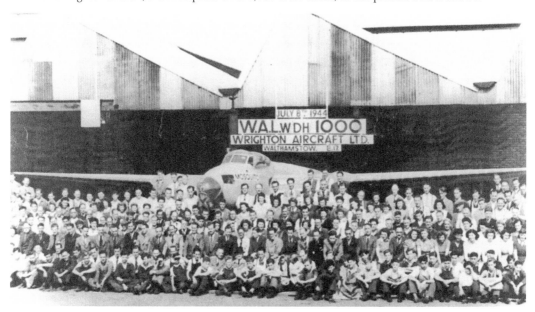

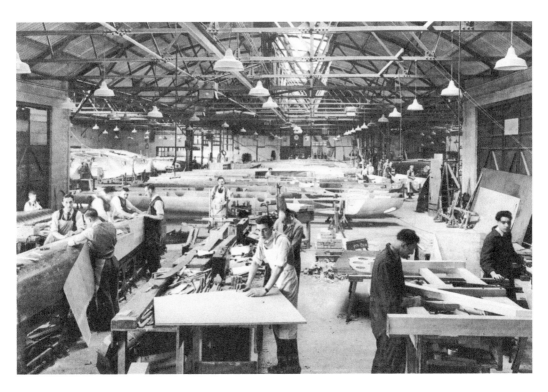

F. Wrighton & Sons Furniture and Mosquito Aircraft Builders

In 1940, a subsidiary called Wrighton Aircraft was set up in Torquay, which made parts for various aeroplanes, including the Short Sunderland Flying Boat. After the Second World War, the company returned to furniture making, as the advert (*opposite page, above*) shows. The old Brampton Works building was demolished in the 1970s and is now part of a new industrial estate.

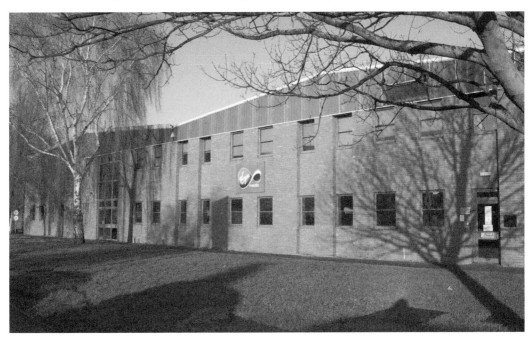

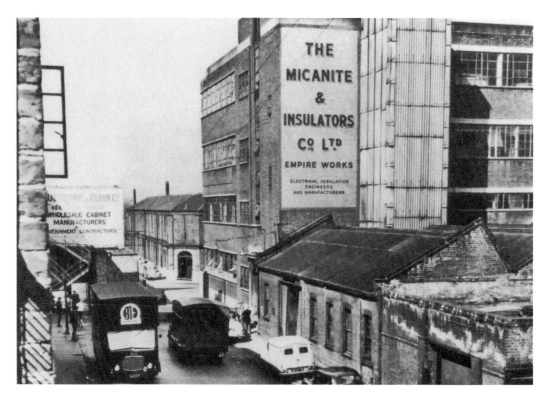

The Micanite & Insulators Co. Ltd

The company was founded in 1901 at Stansted Mountfitchet as the Mica Insulator Co., but moved in 1902 to Empire Works in Blackhorse Lane, Walthamstow, as shown in the picture above. The company made insulating materials, and employed a larger number of women and girls. The factory was enlarged in 1907 and again in 1928/29, when associations were formed with Associated Electrical Industries and English Electric. In 1939, another associate company, British Tego Gluefilm Limited, went into production. The amount of employees working in the factory was about 600 during the First World War; however, this had increased to 1,700 by 1955. By 1961 they were producing mica, micanite, silicone insulation, empire varnished insulation, high voltage bushings and insulators, and at this time they were employing 1,600 people. In 1969, the company had become part of General Electric and English Electric Companies Ltd. Production then moved to Trafford Park and the factory closed.

Peter Hooker Ltd

Peter Hooker Ltd was founded in Blackhorse Lane in 1901 as a printing and engineering company. In the First World War, the factory was converted to produce aviation engines. These were produced on licence instead of in France. The type of engine produced was the Gnome Le Rhône. Many of these rotary engines were used in the First World War on the Avro 504 aircraft, bringing another connection with Avro to Walthamstow. One such engine made with Peter Hooker Ltd Walthamstow stamped on it is now preserved by the Museum of Scotland. The company closed in 1921. Most of the company's Walthamstow records were destroyed by a fire, but these two very rare pictures have been found for this publication. A road close to the old site of the factory has been named Hookers Road.

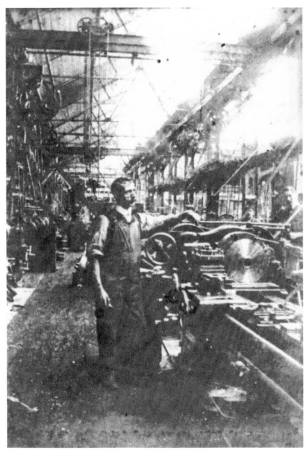

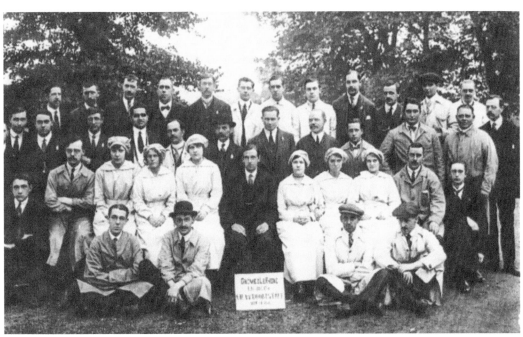

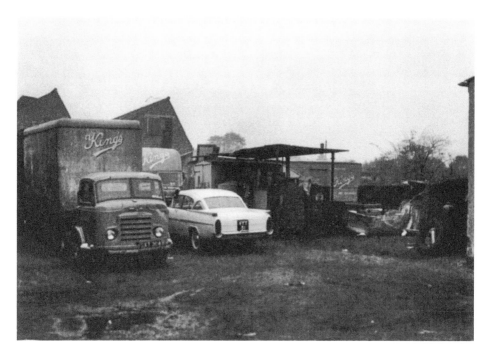

Kings Laundry, Billet Road

Kings Laundry was situated in Billet Road. Not much is known about this company except it was one of a number of laundries within Walthamstow. The most famous of these was Achille Serre Ltd in Blackhorse Lane. Our top picture shows the back of Kings Laundry in Billet Road and the bottom shows the inside of the factory. The company closed in 1961 and its contents were auctioned on 30 October 1961. The old factory building was demolished in 2013.

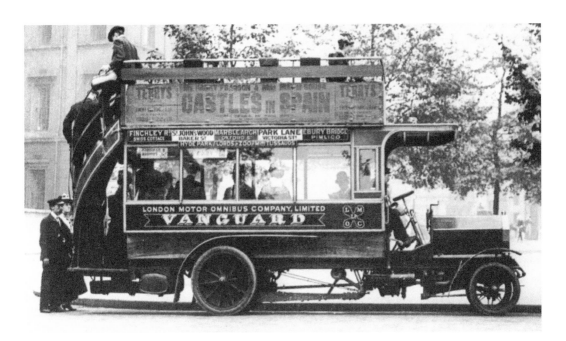

The Associated Equipment Company, Walthamstow, 1912–33

The origins of this company go back to the early 1900s when a London stockbroker, Arthur Salisbury Jones, had a vision to both control and build Britain's buses. He set up the London Motor Omnibus Company, with a small factory in Hookers Road. This soon began to expand. Besides building his own buses, he also purchased a number of Miles Daimler buses and started to run bus services. Above is one of these Miles Daimler buses with the company trading name, Vanguard, on its side, and on the right is a map showing the last routes that the company ran in London on 30 June 1908, when it was taken over by the London General Omnibus Company.

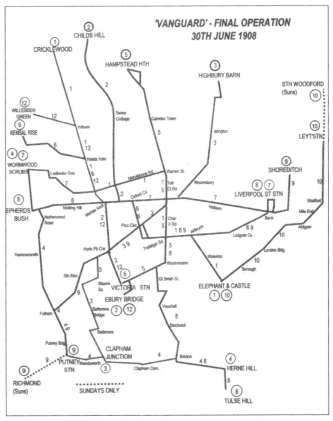

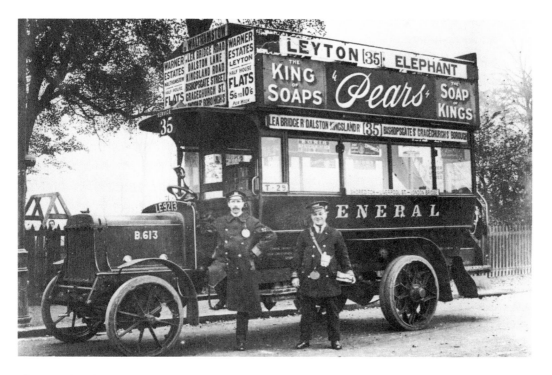

The Associated Equipment Company, Walthamstow, 1912–33

As the London Motor Omnibus Company's finances began to be stretched due to overexpansion at Walthamstow and falling passenger numbers, the company found itself with the unfortunate choice of either going bankrupt or selling the business. The decision was taken for the London General Omnibus Company to fully take over the operations at Walthamstow. With the same concept in mind of building motor buses, production began to take place at Walthamstow, firstly with a prototype called the X and then the mass production of the B-type, shown above.

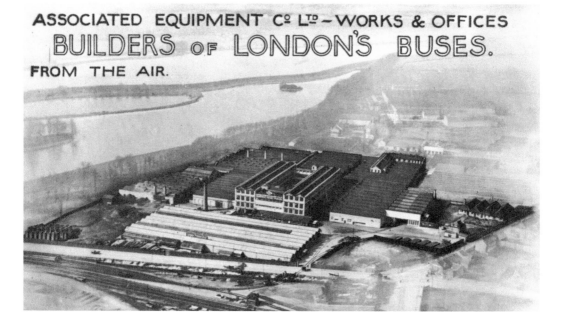

ASSOCIATED EQUIPMENT Cᵒ Lᵀᴰ ~ WORKS & OFFICES
BUILDERS of LONDON'S BUSES.
FROM THE AIR.

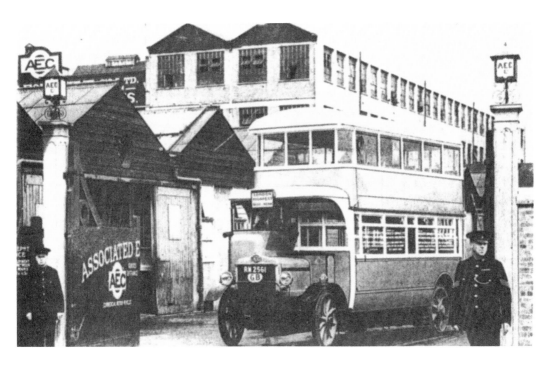

The Associated Equipment Company, Walthamstow, 1912–33
The Underground Group started to buy up the London General Omnibus Company's shares, as it was losing out to the company's bus operations in London. By 1912, the Underground Group had gained control of the company; however, the Underground Group also wished to continue with the building of buses and commercial vehicles at Walthamstow. The company then decided to start a new trading arm that would enable them to do this. The new company's trading name was the Associated Equipment Company, known today by millions of people all around the world as just AEC. Pictured above is a bus leaving the factory in Ferry Lane, and below is the site today.

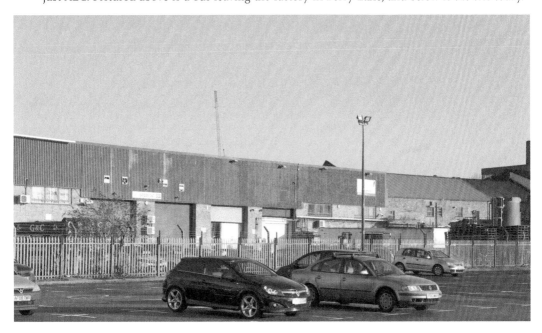

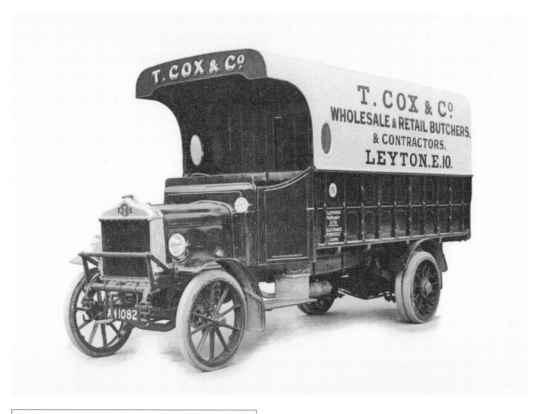

The Associated Equipment Company, Walthamstow, 1912–33

With the arrival of the First World War,
the development of motor buses in Britain
ground to a halt. By then, AEC had been
producing around twenty-eight new B-type
buses per week, with a grand total of 3,000
finally being produced. Not all of these
were open-top double-deckers; charabancs,
single-deckers, lorries and parcel vans
were all being designed and constructed
around the B-type chassis. The war years
were a severe test for the vehicles and
those at Walthamstow responsible for their
production. The B-type bus was adapted
as a troop carrier, with some 1,300 being
acquired by the War Department. Most
of them saw service in France, hence the
famous saying 'Born in Walthamstow, Died
in France'. During this wartime period,
the buses were also nicknamed 'The Old
Bill Bus'. However, a far greater test was
now placed on the company as it was also
entrusted with the production of thousands
of trucks for military duties.

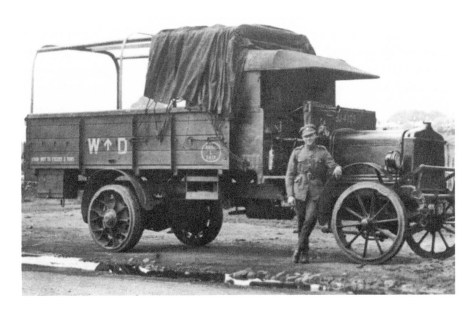

The Associated Equipment Company, Walthamstow, 1912–33

A new, robust, pressed steel frame vehicle was required, to be powered by a 45 hp petrol engine and have a four-speed crash gearbox, which would be able to carry a heavy load. Enter the Y-type 3–4 ton lorry. By the end of the First World War, 10,000 had been manufactured in Walthamstow, representing 40 per cent of the total vehicles built for the three Armed Forces. The company then decided to promote its products on the world market. This resulted in a new sales and advertising department being established. It was now time for new types of buses to be designed by the company. The first of these was the K-type in 1919, which had twelve more seats than the B-type and a 30 hp engine mounted for the first time to the right of the driver. We are now entering the final phase of the factory at Walthamstow, as it had now become too small for the company to continue its existing operations there.

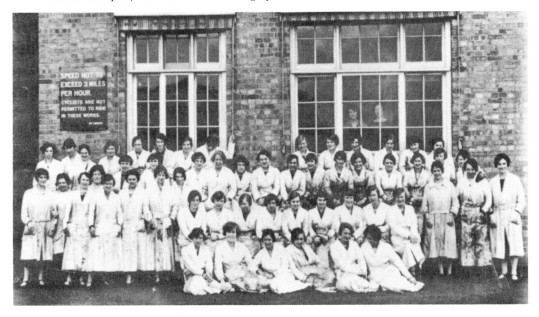

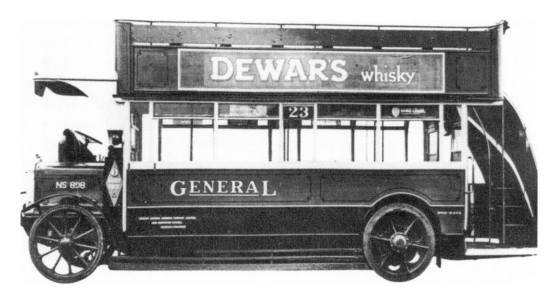

The Associated Equipment Company, Walthamstow, 1912–33

The year 1922 saw the first types of AEC trolley buses being produced at Walthamstow. New bus designs continued to be developed and in 1923 the NS-type model appeared, which was the last model produced at Walthamstow. Although the factory appeared to close down in 1927, tractors were still built on the site until 1933. George Rushton, who worked as an engineer for the company, persuaded his employers to let him design a tractor that would be able to compete with Henry Ford's ubiquitous Fordson. Rushton's first tractor appeared in 1928 as the 'General', but this was soon changed to 'Rushton'. By 1927, most of the operations had moved to Southall in West London. Also in 1927, a notable milestone in the development of bus building came with the first six-wheeled double-decker. It was a giant of a bus, which was upgraded to an amazing world-record 104-seater vehicle and was used to transport the company's employees from Walthamstow to Southall, as many of them still lived in East London.

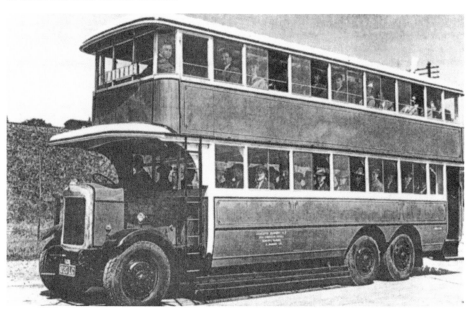

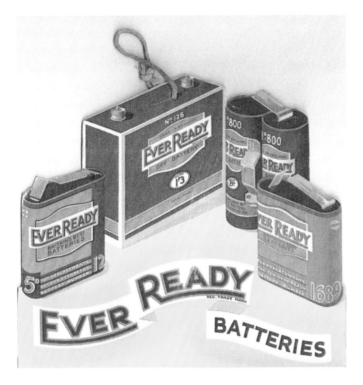

Ever Ready Batteries and Ensign Camera Makers

Ever Ready Batteries started in Walthamstow in 1933. The company occupied the old AEC bus works in Ferry Lane and the company manufactured radio high tension batteries and dry cell batteries for electric torches, employing 2,000 people. However, Ever Ready also made batteries for use in motor cars and motorcycles. Many of their products were also designed for use in mines, submarines and other high-risk places. From 1908 to 1954, there was a large camera-making factory in Fulbourne Road, Walthamstow. It was known as the Ensign Works and was on the opposite side of the road to the ASEA & Fuller factories. By 1949, the company employed some 800 workers and claimed to be the biggest camera manufacturer in Europe. The old works building was demolished in 2013.

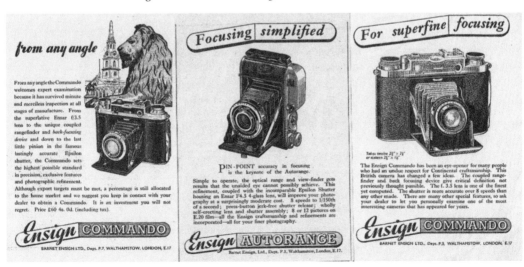

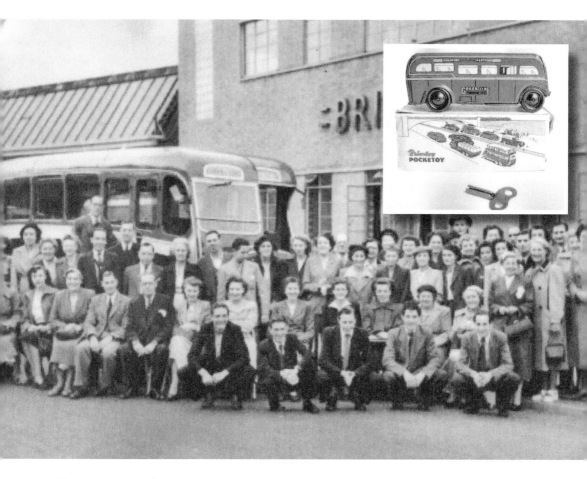

Walthamstow Toy Makers

There were a number of toy manufacturers that set up their home in Walthamstow. The most famous of these is Britains, who started up in Sutherland Road in 1958. Having originally used lead, the dismantling of the wartime radar system allowed them to begin manufacturing toys in polythene. The company relocated to Blackhorse Lane in 1968 and was taken over by Dobson Park Industries in 1984. Some of the old range of models are still being made today. Our picture above shows the staff going or having just been on an outing somewhere. Our next company, Wells-Brimtoy, started life as two separate companies: Brimtoys in 1923 and A. Wells & Co. Ltd in 1919. The latter set up home at Somers Road, Walthamstow. The amalgamation of two companies took place in 1938 when a new large works in Stirling Road was built. As seen in the inset, they made tin plate trains, cars, buses and lorries, often with clockwork parts, in particular for its 'O' gauge railway models. By 1949 it was employing around 700 workers. Later on in the century, there were takeovers and mergers with other firms and Wells-Brimtoy moved to Anglesey in 1964. This concludes our section on some of Walthamstow's industrial companies.

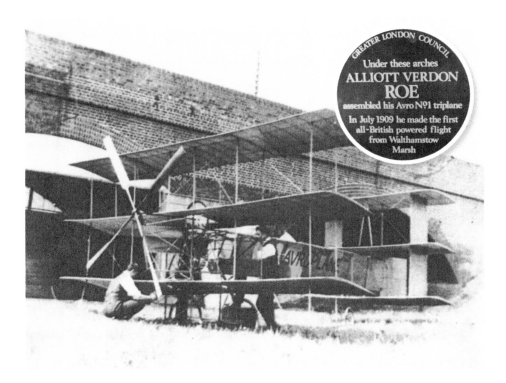

Under these arches
ALLIOTT VERDON
ROE
assembled his Avro N°1 triplane
In July 1909 he made the first
all-British powered flight
from Walthamstow
Marsh

Avro

On 13 July 1909, Walthamstow was once again set to be written in to the annals of Britain's historic transport achievements. This time it was aviation, as on Walthamstow Marshes the first all-British flight by Alliott Verdon Roe was made. The engine used to power the plane was a 9 hp JAP Engine made in Tottenham. Roe then decided to mass-produce aeroplanes and A. V. Roe & Company was formed in 1910. The first model was the famous 500-type. In 1929, Roe was knighted for his services to the development of aviation. Over its many years, Avro produced a number of unique planes, the Lancaster and the Vulcan bomber being just a couple. A commercial model of the Lancaster, the Lancastrian, was the first commercial aircraft to fly from Heathrow, London. The Lancaster bomber was also adapted in the Second World War to carry the famous Barnes Wallis 'Dambuster' bouncing bomb, which was partly designed at the Royal Gunpowder Mills at Waltham Abbey. In 2009, a centenary celebration was held on Walthamstow Marshes, where this historic aviation achievement took place.

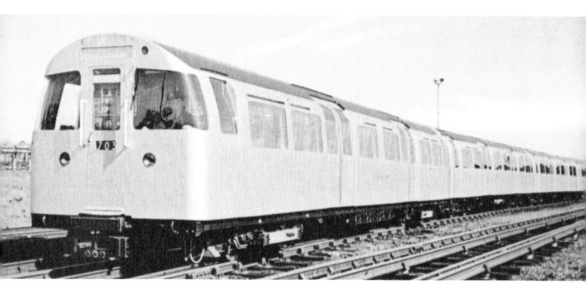

The Victoria Underground Line

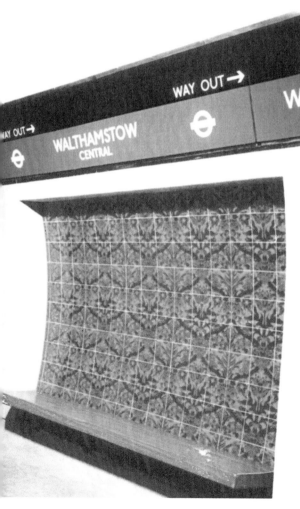

The Victoria Underground Line was the first fully automatic underground railway in the world. It was opened in 1968 between Walthamstow and Highbury & Islington. The above picture shows a Victoria Line train as new in 1967, and the picture below shows the new stock. Only 2⅓ sections of the original 1967 Victoria Line carriages have now been preserved: driving car No. 3052, which was the driving car from which Her Majesty Queen Elizabeth II officially opened a section of the line on 7 March 1969, and car No. 3186, which has a unique prototype interior layout. The preserved third section is car No. 3016, which is the only surviving car that has not been refurbished. Car No. 3052 is stored at the London Transport Museum depot at Acton, and cars No. 3016 and No. 3186 are part of the Walthamstow Pumphouse Museum collection. The picture on the left shows the platform seat at Walthamstow Central station. The wall tiles behind are of a William Morris design.

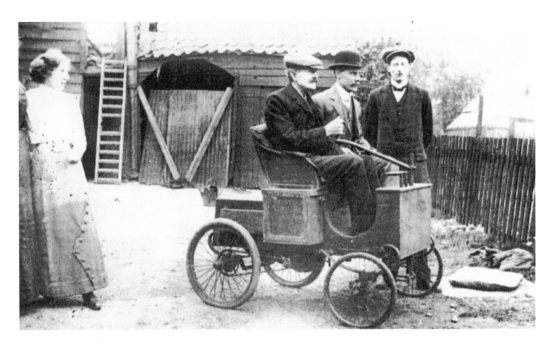

Britain's First Car

This was another milestone in the history of Walthamstow's transport heritage. One of the most unique stories in the history of the British car is that of the inventor Frederick Bremer (1872–1941). Bremer was a plumber by trade who had a fascination for cars. In 1892, Bremer built Britain's first four-wheeled car powered with an internal combustion engine in his small workshop at the rear of a house in Connaught Road, Walthamstow. It is said that this was Bremer's second car, the first being gas-powered. However, there does not seem to have been any attempt to put his second car into mass production, as Bremer apparently built the vehicle by the way of a personal challenge. The picture above shows him driving the car, and below the car today in the Vestry House Museum in Walthamstow Village. A series of vintage car runs called the Bremer Run celebrating this and the borough's other transport achievements have been held in the past.

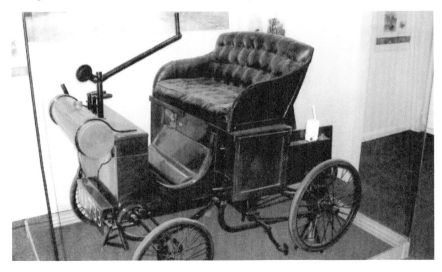

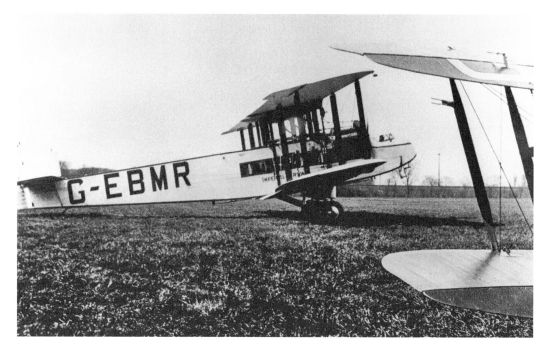

Sir Alan Cobham Air Shows at Low Hall

Another aviation first for Wathamstow took place in April 1932, when Alan Cobham brought his flying circus or national aviation display to the Low Hall Sports Ground. The event was attended by the then Mayor of Walthamstow, Tom Smith JP. A report in the *Walthamstow Guardian* of Friday 29 April 1932 stated that thousands of people flocked to the temporary aerodrome and were not disappointed. It was really a special event, with rides given to the public on various aircraft and flying displays that would have given today's health & safety executive a heart attack. I have included four pictures of the air show, which is only fitting for such a great event. Alan Cobham went on to invent the in-flight refuelling system and achieve many solo long-distance flights. He was knighted for his services to aviation in 1926.

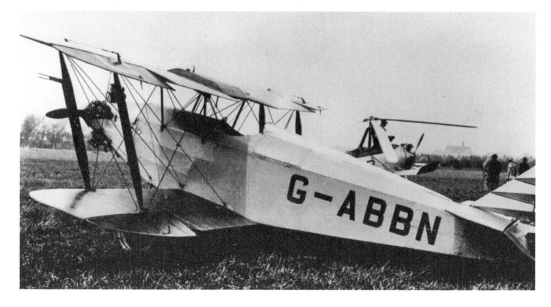

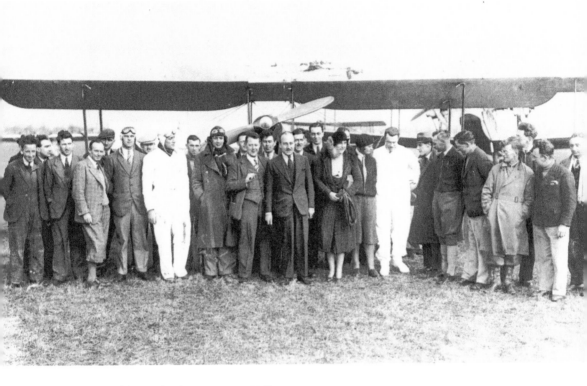

Sir Alan Cobham Air Shows at Low Hall

The two photographs show Sir Alan Cobham and his aviation day display team (*above*), and the flying display in the air (*below*).

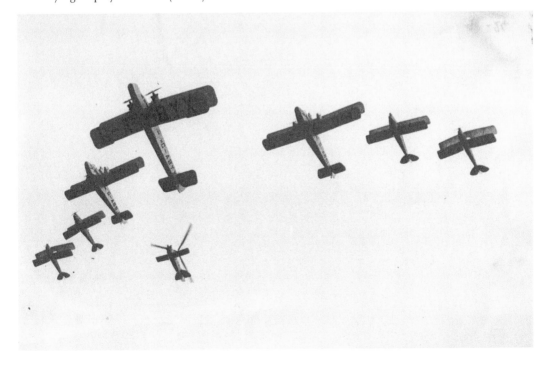

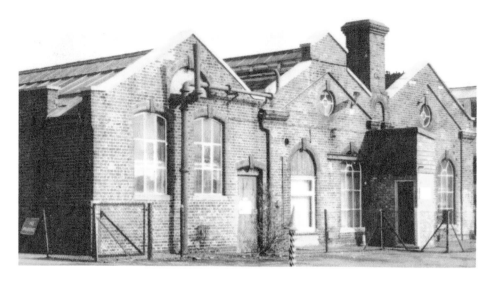

The Walthamstow Pumphouse Museum Project

The museum project was started by the author of this publication in 1994 with a group of like-minded local people. The objective was to save the Low Hall Victorian Pumping Station for the benefit of the public and future generations and so that the region's historic industrial past could be celebrated. A lot has been achieved since 1994 in developing the current museum site. The museum's trust hopes to open the site up for more days in the near future so that it can become a major local museum attraction for the region. The pump house building and its 1897 Marshall C class steam engines within are Grade II listed. Built in 1885 for the Walthamstow Urban District Council, the former sewage pumping station and its surrounding land have seen many changes over the last 100 years. The museum now holds a large collection of fire equipment, vehicles, Underground cars, pumps, aviation models and many railway artefacts, which will be displayed in 2014 when the works to the pump house building and the new display areas have been completed. Our picture above shows the building when we first started the project and below is the building today.

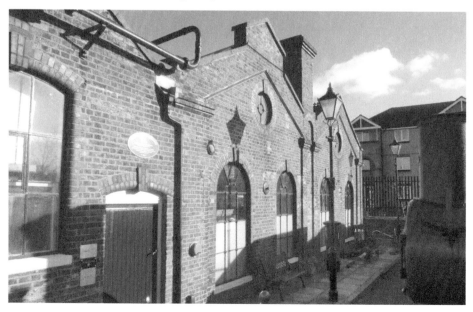

The 1897 Walthamstow Pump House Marshall C Class Steam Engines and Original Pumps

In 1897, the two 1885 old pump house bays were enlarged and a third bay was added to the left of the building. The Marshall C class steam engines, boilers and plant equipment were also added at that time. However, no plans of the 1897 extension have been found to date. The picture below shows the 1897 Marshall steam engines. The Hayward Tyler steam pumps (*right*) were installed in the pump house in 1885 but have long since been removed.

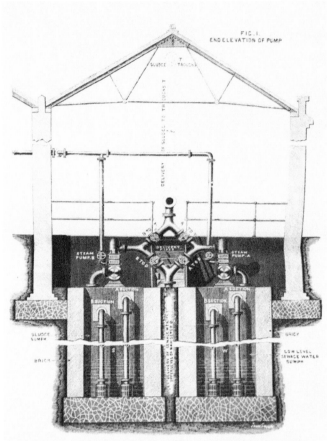

Arrangement of HAYWARD TYLER & CO.'s Steam Pumps for Sewage and Sludge at Walthamstow Sewage Works.

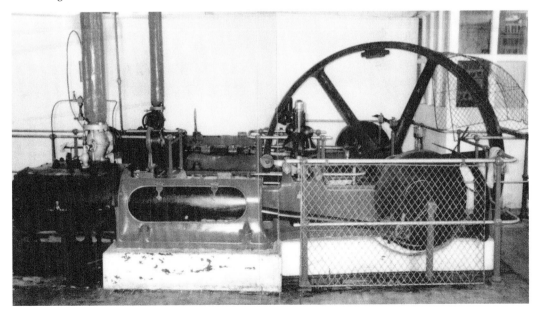

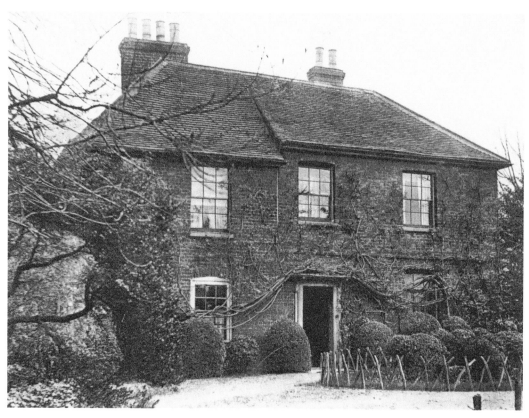

The Low Hall Story

(An Account of Walthamstow's past)

Comittissa Judith Earl Waltheof

BETRAYED

PATRICIA COLLIER

The Walthamstow Low Hall Manor House and Farm

This building once stood close to the Low Hall pump house site. It has been proposed to celebrate the history of the owners and residents of the manor house in an exhibition in the Pumphouse Museum in the future. These will include the Earl Waltheof, Countess Judith, the Earl of Warwick (the Kingmaker) and Sir Ralph Sadler, one-time guardian of Mary Queen of Scots. In 1997, the manor house site was excavated and several artefacts were uncovered. Interestingly, part of a V1 flying bomb was discovered, which destroyed the Low Hall farmhouse building in 1944 (*above*). A book on the story of Low Hall was written by the author's late mother, but never got published. In a tribute to her, the cover of this proposed publication is also shown.

Early Public Transport in Walthamstow

The first recorded public transport service provider in Walthamstow was John Gibson, who began a coach service in 1707 from Marsh Street (now the High Street) to Leyton. The company was sold to Joseph Schooling in 1758, who then sold the business to Francis Wragg in 1759. In 1764, Wragg's started services to the City of London, running from the office in Marsh Street by the Chequers public house, as well as the Nags Head in Walthamstow Village. The coach shown above was painted yellow and could carry eighteen passengers. A horse bus service to Lea Bridge, regarded as Walthamstow's first station, was started in 1840. With the railways now coming directly to the heart of Walthamstow, Wragg's coach services ceased to operate in 1870. The council resisted for some time to build its own tramway, but did allow horse bus services to operate from the Higham Tavern, as shown in the picture below, to Hoe Street and on to Stratford in 1889. By this time, the horse-drawn tram services were operating along the borough's boundary from Lea Bridge Road to Woodford via the Bakers Arms.

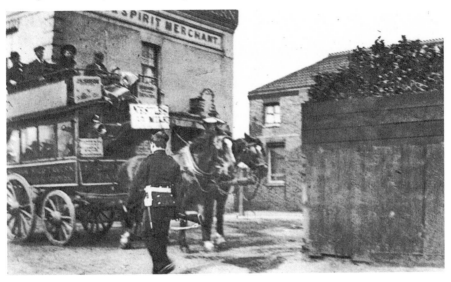

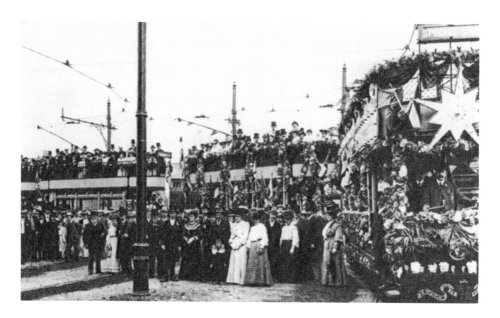

Tramways in Walthamstow

The history of the tramways in Walthamstow starts in 1903 when a Light Railway Order was authorised to the Walthamstow Urban District Council to start electric tramway services on 3 June 1905. A picture of the opening is seen above. The depot was in Chingford Road and had a splendid terracotta office to the right of the entrance, which is today a listed building, as seen below. The construction of this started in 1904. A bogus coat of arms was initially attached to the side of all the cars, which was removed in 1929 when the borough became charted. This was replaced with the borough coat of arms, as seen at the start of this publication. The livery of the tramcars was a crimson lake and chrome yellow, with dark brown trucks and red numerals with a gold border. The contract for the construction work of the track and electrical equipment was awarded to the famous Dick, Kerr & Company. The tramcars were built by various companies.

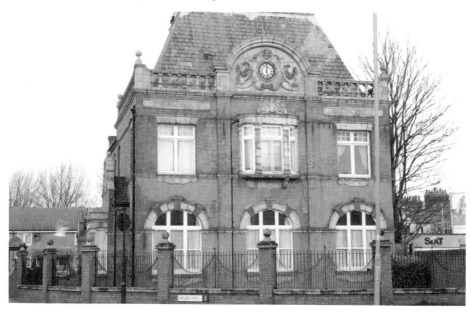

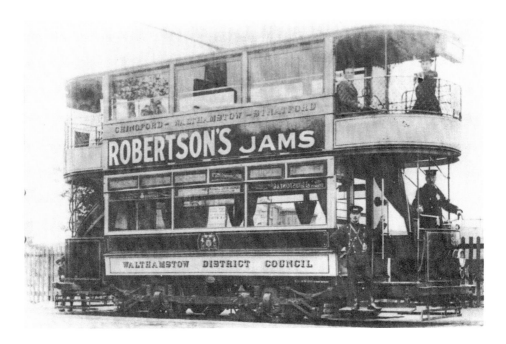

Tramways in Walthamstow

The Walthamstow Corporation owned sixty-two tramcars and operated nearly 9 miles of track. A picture of a Walthamstow Corporation tramcar is shown above. As the tramways within East London began to grow, Walthamstow tramcars started to work through services to destinations outside the borough. This continued right up to when buses and trolley buses fully replaced the tramcar services in the borough. The operations of Walthamstow's tramways were handed over to the London Passenger Transport Board on 1 July 1933. The last tram ran on 12 June 1937. Many tramcars were scrapped at Walthamstow at the back of the depot, as our picture below shows.

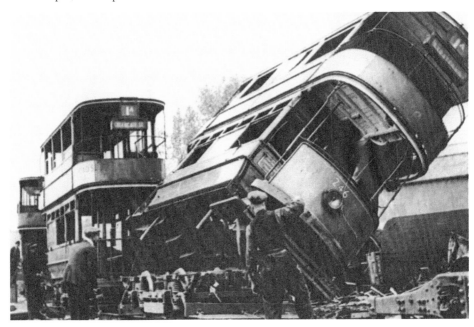

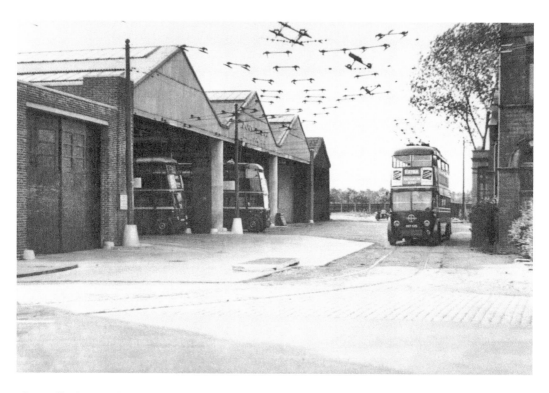

The Trolleybus Replaces the Tramcar

As the last tramcar arrived back at the depot, the trolleybuses were ready to take over, as the above picture shows. Note the tram tracks are still in situ. By this time, buses were also operating over many of the routes that the tramways had run in the past. The picture below is of the last trolleybus in service on the 699 route arriving back at Walthamstow Depot on 21 April 1960.

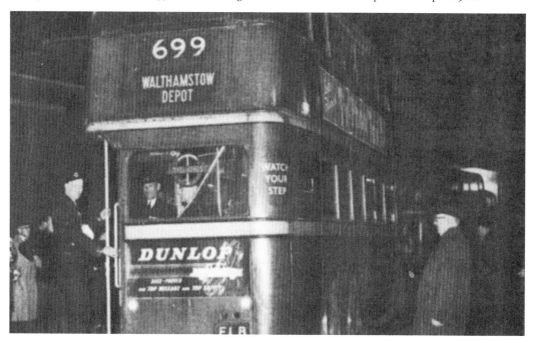

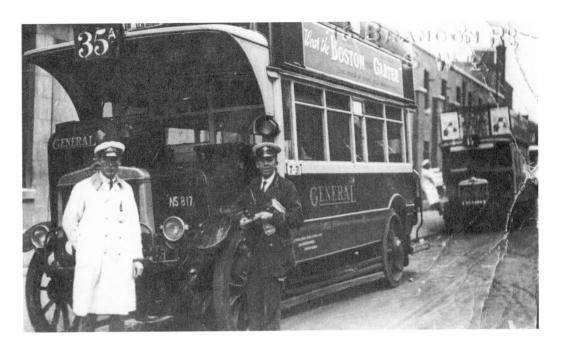

Bus Travel in Walthamstow

Walthamstow's bus service has evolved from a bone-shaking stagecoach to today's clean and well lit buses, with comfortable seats. Modern technology has also enabled the travelling passenger of today to see an illuminated information sign at the bus stop to find out when the next bus will arrive. Before this you did not know if the bus was on time, or even if it would come along! The author's wife's grandfather, who was a conductor, can be seen on the right in the above picture.He is standing in front of NS-type bus No. 817, which was built at Walthamstow in 1923 and ran on the 35A route. The picture below shows a modern bus of today on the 58 bus route.

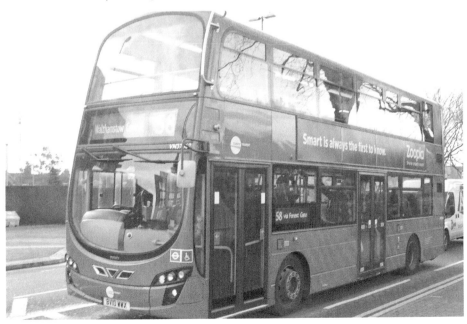

MURDEROUS OUTBREAK OF RUSSIAN ANARCHISTS IN LONDON: THREE KILLED, MANY INJURED. HEROIC POLICEMAN AMONG THE SLAIN.

The Tottenham Outrage (The Walthamstow Tram Chase)

Continuing on our transport theme, this story must be told as it made the national newspapers and involved at least two Walthamstow Corporation tramcars. On 23 January 1909, a wage snatch took place in Tottenham when £80 was stolen from a factory in Chesnut Road by two armed extremists, Jacob Lepidus and Paul Helfeld, who were from Latvia. The reason for the robbery was that they required money to fund their cause. The two robbers were then chased from Tottenham and across the marshes to Sailsbury Hall Farm, Chingford, by the public and police officers. In order to get away from the pursuing mob, they hijacked a passing Walthamstow Corporation tramcar in Chingford Road, which headed off towards Walthamstow Tram Depot. This was followed by a second tramcar, commandeered by the police, who were in hot pursuit. Gunfire was exchanged, with bullets hitting at least one of the tramcars. What happened on that day was described as an outrage (hence the name Tottenham Outrage) but it is better known in Walthamstow as the Walthamstow Tram Chase. Above is the front page of the *Daily Mirror* covering this story on Monday 25 January 1909. Below is an image of a robber holding a gun to the tramcar driver's head. Inset is a proposed cover for the book written on this story by the author's late mother.

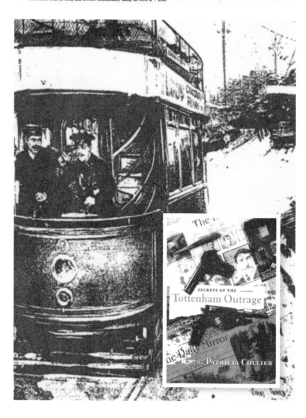

SECRETS OF THE
Tottenham Outrage
BY PATRICIA COLLIER

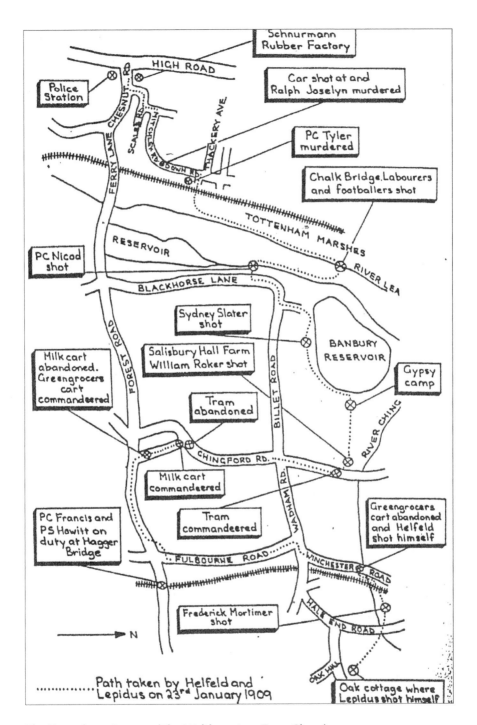

The following labels appear on the map:

- Schnurmann Rubber Factory
- HIGH ROAD
- Police Station
- Car shot at and Ralph Joselyn murdered
- CHESNUT RD.
- SCALES RD.
- MITCHLEY RD & DOWN RD
- THACKERY AVE.
- FERRY LANE
- PC Tyler murdered
- Chalk Bridge, Labourers and footballers shot
- RESERVOIR
- TOTTENHAM MARSHES
- PC Nicod shot
- RIVER LEA
- BLACKHORSE LANE
- Sydney Slater shot
- BANBURY RESERVOIR
- Gypsy camp
- Milk cart abandoned. Greengrocers cart commandeered
- FOREST ROAD
- Salisbury Hall Farm William Roker shot
- BILLET ROAD
- RIVER CHING
- Tram abandoned
- Milk cart commandeered
- CHINGFORD RD.
- WADHAM RD.
- Tram commandeered
- Greengrocers cart abandoned and Helfeld shot himself
- PC Francis and PS Hewitt on duty at Hagger Bridge
- FULBOURNE ROAD
- WINCHESTER ROAD
- Frederick Mortimer shot
- HALE END ROAD
- OAK HILL
- Oak cottage where Lepidus shot himself
- → N
- Path taken by Helfeld and Lepidus on 23rd January 1909

The Tottenham Outrage (The Walthamstow Tram Chase)

Above is a map of the chase, which ended in Oak Hill with Helfeld giving up. He later died of shotgun wounds. The other robber, Jacob, being trapped in a house, decided to commit suicide. Two other people died in this tragic event. They were Constable Tyler and a ten-year-old boy. More than twenty people were also wounded. The stolen money was never found. A silent film was also made about this story.

Walthamstow Theatres & Cinemas

There were a number theatres and cinemas in Walthamstow, with some being more famous than the others. The earliest recorded theatre in Walthamstow was in Orford Road and was built in 1866. In the High Street once stood the majestic Palace Theatre, which was built in 1903. It closed in 1954 and was demolished in 1960. Various front covers of the programmes from the theatre are shown on this page.

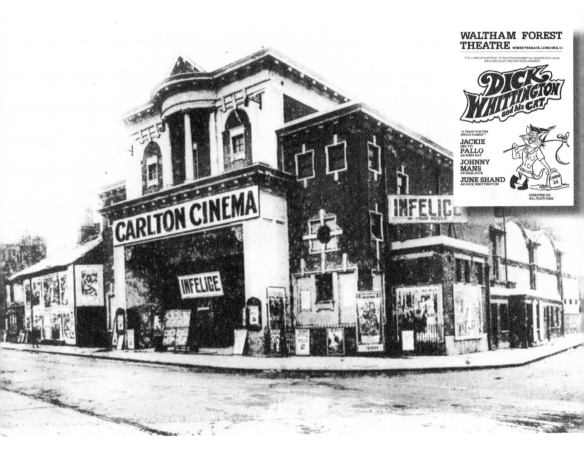

Walthamstow Theatres & Cinemas

The Lloyd Park Pavilion and Theatre was built by the borough council in 1937 and was demolished in 2012 to make way for a larger park. The author spent many happy hours there over the years watching his daughter appear in various Christmas pantomimes organised by the Jennifer Haley Stage School. A programme is shown inset. Moving on to the Walthamstow cinemas, how many can you name? Among Walthamstow's cinemas were the Arcadia (1912–24); Wood Street Picture Palace (1912–55); the Bath Halls Cinema in the High Street (1900–12); the Electric at Bell Corner (1913–81), the Princes (1910–30) and the Royal (1911–13), also in the High Street; the Queens (1911–40) and the Victoria Hall (1887), both in Hoe Street (1911–39); and the St James Electric Picture Palace in St James Street. The better-known Carlton Cinema was in the High Street. It opened on 13 November 1913 as a 1,400-seater cinema. By the 1920s, it also had its own orchestra and organ. It closed on 14 August 1959, but was reopened by the Victor Cinema Ltd group until 28 March 1964. It was demolished in 1986. A picture of the Carlton is shown above.

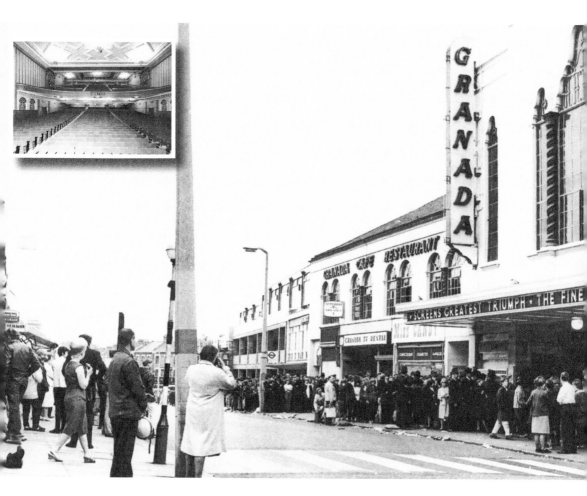

Walthamstow Theatres & Cinemas

We now concentrate on the rise and fall of the Walthamstow Granada, or the EMD as it is known today, in Hoe Street. Once a Cannon Cinema, it stands on a site that has provided entertainment to the borough for over a century. The Victoria Hall was opened on 2 May 1887 as a venue for dances, meetings, concerts and plays. It later became the King's Theatre, but reverted back to its original name in 1907 and became a full-time cinema. It was then purchased by Cecil Bernstein of Granada Theatres, who decided to build a more modern Super Cinema on the site. In 1930, the old Victoria Hall was then demolished and the new Walthamstow Granada Cinema opened on 15 September 1930. The cinema also had an excellent stage and facilities; hence it was used many times also for shows and concerts. Our picture shows above shows people queuing for the first Beatles show. In 1954, the Granada also became the first cinema in the area to show a film in Cinemascope. On 16 October 1973 it opened again as a triple-screen cinema. At this point, we must also mention the theatre's Christie organ, which was once played by a Harold Ramsay, said to be at one time the highest paid organist in the world. The inside of the theatres was once as spectacular as our picture below.

Walthamstow Theatres & Cinemas

The cinema became part of The Cannon Group in 1989, and was then operated by Odeon until being sold to EMD cinemas in 2000. After trying for a number of years to make the cinema viable, the final nail in the coffin for this grand old lady was the coming of the home cinema video age. In 2003 the cinema was closed and sold to the Universal Church of the Kingdom of God (UCKG) to be used as a church, which was similar to the fate of the Astoria Finsbury Park. As the old cinema was an art deco listed building, a group of like-minded people got together, called the McGuffin Film Society, to have the building returned to its original use as a cinema. Despite a long campaign by the McGuffin group and huge public support, along with the council refusing to grant planning permission to the church group for the building to use as a church, the cinema today still remains empty. We can only now surmise as to the condition of the interior of the building today, or what the fate of this great cinema will finally be... With the construction now well underway of a new purpose built cinema next to the EMD, as shown in our photograph below, perhaps the old building could be used as a facility for the arts, dances, concerts, meetings and plays for which it was first built. The top picture shows the old arcade building, now demolished, leading up to the Granada.

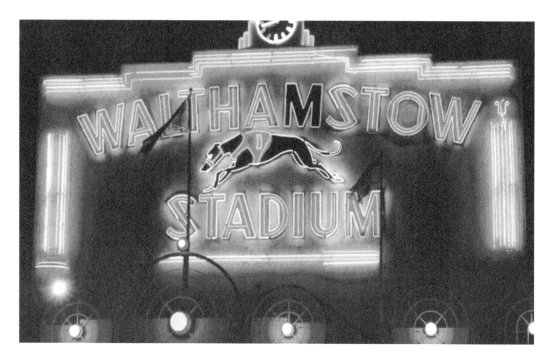

Walthamstow Stadium Gone to the Dogs

Having lived in the borough for over forty years now, I have enjoyed many visits to the Walthamstow Stadium, mainly for greyhound racing, and it was a sad day when it closed in 2008. Whatever the reasons behind its closure are, it is a great loss to the borough. Today, the 'Stow', as it was known to many, has now become derelict, awaiting the construction of new housing. The picture above shows the stadium's once fantastic illuminated façade, now dark. Many people will, however, look back nostalgically at its 'glory days', and forget that motorcycle speedway and stock car racing were all also once a key part of the stadium's yearly events programme. Speedway took off in the UK just down the road in High Beech, where its first-ever race in 1928 drew a huge crowd of 3,000 people. Its popularity wildly exceeded organisers' expectations, and it wasn't long before the craze spread. The picture below shows the condition of the stadium as it was in December 2013. As it is now a listed building, I hope that a future picture of it is better to look at.

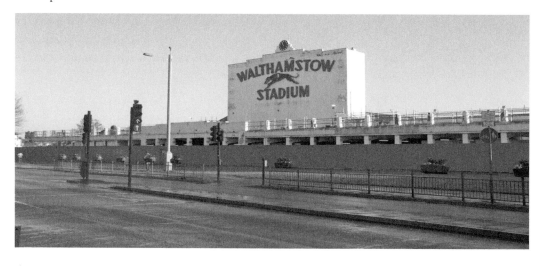

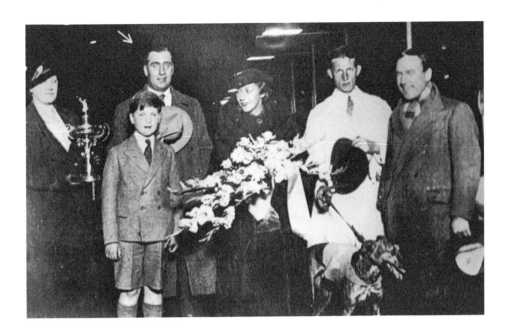

Walthamstow Stadium Gone to the Dogs

The stadium was opened in 1933 by William Chandler and run by the Chandler family until the day it closed in 2008. The final race was held during meeting 152 on Saturday 16 August 2008 at 11 p.m., and the winner of the race was trap 2 'Mountjoy Diamond'. The rich and famous were always seen at the Stow. The picture above shows the famous aviator, Amy Johnson, the first woman to fly solo from England to Australia. She is in the middle of the picture with the flowers, and her husband, Jim Mollison, also a famous aviator, to the far right of the picture. In the front of William Chandler (arrowed in the picture) is Victor Chandler. The picture was taken in 1935. The name of the dog from trap 2 and winning owner is not known. The picture below was taken in 1949 with the famous film star Lana Turner, and the late Charles Chandler on the right. Lana Turner's husband, the millionaire Bob Topping, who brought midget car racing to the Stow, is to the left of the picture.

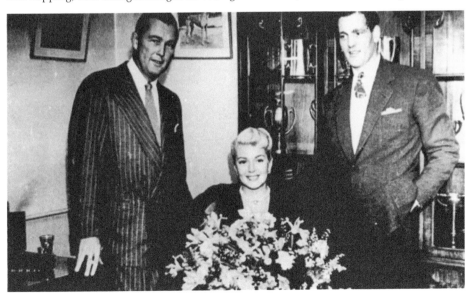

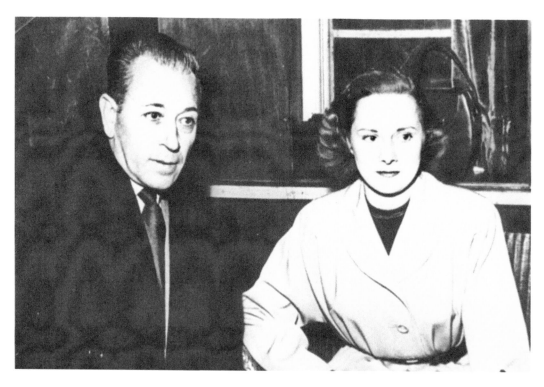

Walthamstow Stadium Gone to the Dogs

On this page, you will find another two pictures of the rich and famous enjoying a night out at the Stow. The above picture shows George Raft. Can you name the people in the picture below?

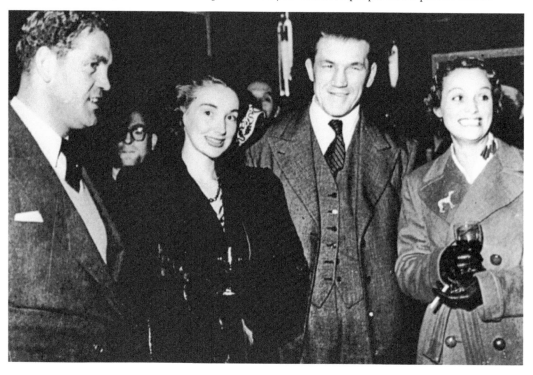

Walthamstow Stadium Gone to the Dogs
On this page and the next you will
find various programme covers and
flyers from events that took place at the
stadium. To the right is the cover from
the greyhound race meeting of Saturday
19 November 1955. Below you will find a
flyer of a speedway meeting between the
Wolves *v.* Yarmouth.

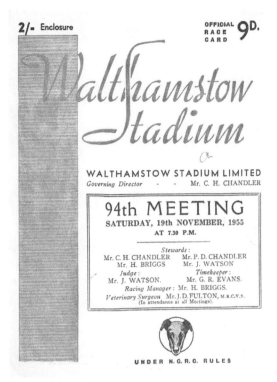

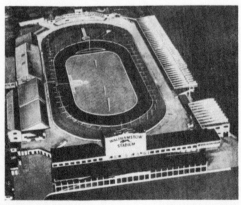

Walthamstow Stadium Gone to the Dogs
Besides greyhound and speedway racing, other events such as midget car and stock car racing, show jumping and speedshows took place at the stadium, Above you will find the cover of the official programme of a horse show that happened on Thursday 15 June 1950, and below the cover of a speedshow programme of Friday 27 November 1970.

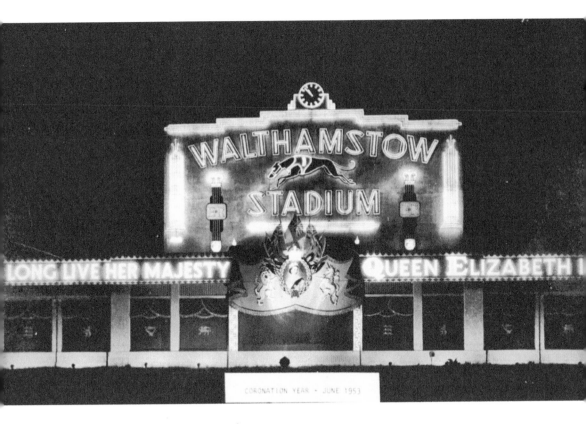

CORONATION YEAR · JUNE 1953

Walthamstow Stadium Gone to the Dogs

Above is a picture taken of the front of the stadium when it was illuminated for the Coronation of Her Majesty Queen Elizabeth II in 1953. In 1984, a nightclub called Charlie Chan's was opened within the foundations of the clock tower, but it closed in November 2007. In 2008, the directors of Walthamstow Stadium Limited agreed to sell the site to a housing development consortium led by London & Quadrant after the studium closed. Despite attempts to buy the stadium back from London & Quadrant and return it to greyhound racing once again, nothing came of this. After protests from the 'Save Our Stow' group and the general public, the Mayor of London, Boris Johnson, approved the development of the site as a housing estate. We have now come to the end of the section on the Walthamstow Stadium – now gone, but never forgotten.

Walthamstow Groups

Above is a souvenir programme from our first Walthamstow group, The Beaucrees, who were formed in 1962. Last year they decided to reform and hold a number of local gigs, which the author attended. They are also planning to perform again in Walthamstow in 2014 at the Orford House Social Club in Orford Road. Like many of the groups from that period, they could (and can still) play their instruments brilliantly. Despite being very popular locally, the group never did manage to get the breakthrough required to become household names, as the competition between groups in the sixties was very fierce. Another local group well worthy of a mention is Sam Apple Pie. Although the author never managed to see them perform, he is a friend of Sam from the band, who today is a local licenced taxi driver.

Walthamstow Groups

Like The Beaucrees, our next group, East End Boyz, pictured on the front of a London Underground train, did not quite make the dizzy heights of stardom, despite once being strongly tipped to become as big as our next Walthamstow group, East 17. East End Boyz was managed by the author and was formed in 1997, but after a number of changes in the group's line-up, the group disbanded. Pictured are members Mark Collier, Darren Marsden, and Tony Roovers. Pictured below in their current format are East 17, who helped put Walthamstow on the national map. Formed in 1991, the band's members were Brian Harvey, Tony Mortimer, John Hendy and Terry Coldwell. Despite various members leaving and rejoining the band, they continue to produce records. They had a number of hits, which included 'House of Love', 'Steam', and 'Stay Another Day'.

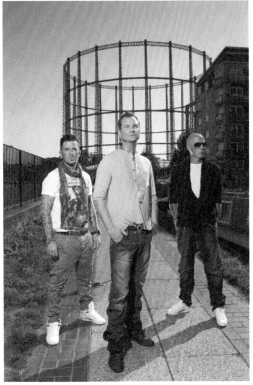

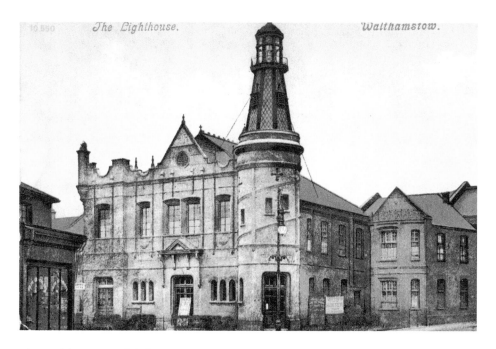

The Lighthouse. Walthamstow.

The Walthamstow Lighthouse

The Lighthouse Methodist church (*above*) was built in 1893. The church is situated on the corner of Markhouse Road and Downsfield Road. The lighthouse has a lantern at the top of the tower, and also contains a spiral staircase. The church was erected through the generosity of Captain David King of the shipbuilding firm of Bullard King & Co. The company ran the Natal Direct Line, which ran ships direct from London to Durban without stopping at the Cape. The shop shown on the corner of the above picture has now gone, to be replaced by part of a car park for a sports centre.

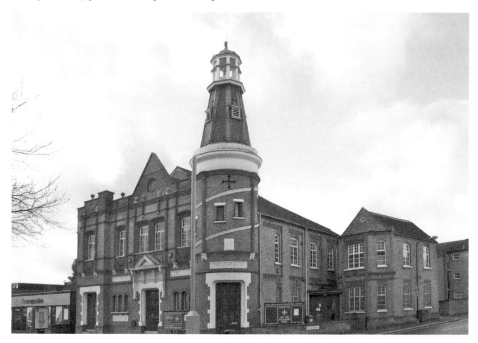

Collier Brothers Brewery

A brewery was first listed on this site in St James Street in 1848. In 1859, there were two, the latter being built by William Hawes and steam powered. In 1871, the Essex Brewery Company Limited was formed to buy out William Hawes' brewery. Failing to attract investors for this scheme, the brewery was then acquired by the Collier Brothers. The brewery then started to retail its own brand of beers in a number of Walthamstow pubs, which included the Brewery Tap, the Tower Hotel in Hoe Street, the Common Gate in Markhouse Road and, finally, the Flower Pot in Wood Street. The Collier Brothers operated their business under the name of the Essex Brewery until 1922, when the business was sold to Tollemache Brewery Ltd. The Brewery Tap pub building still remains on the corner of St James Street and is now a sports centre, but nothing of the brewery remains today.

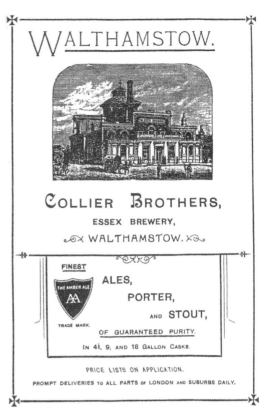

WALTHAMSTOW.

COLLIER BROTHERS,
ESSEX BREWERY,
WALTHAMSTOW.

FINEST

THE AMBER ALE
AA
TRADE MARK.

ALES,
PORTER,
AND STOUT,
OF GUARANTEED PURITY.

IN 4½, 9, AND 18 GALLON CASKS.

PRICE LISTS ON APPLICATION.
PROMPT DELIVERIES TO ALL PARTS OF LONDON AND SUBURBS DAILY.

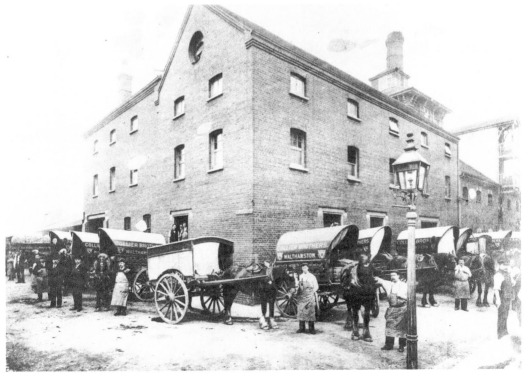

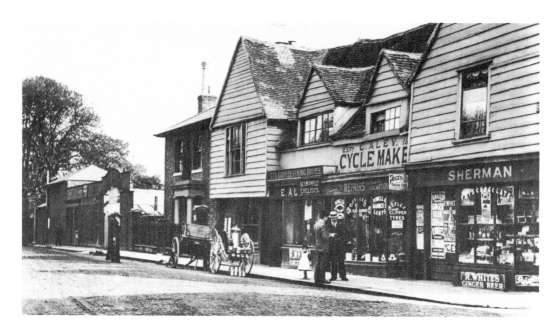

The Ancient House, Walthamstow Village

The Ancient House in Walthamstow Village is a timber-framed hall, believed to have been originally constructed in 1435. The building was continually used for both domestic and commercial purposes, as shown in the above picture, until 2000. However, its chronic decay necessitated the extensive restoration and complete reconstruction of the oak-framed building. The structure is Grade II listed and falls within a conservation area. A full restoration of the building was carried out by a renowned local building company, Fullers Ltd, in 2002, as shown below. Repairs to the building were also carried out in 1934. The building was also once known as the White House.

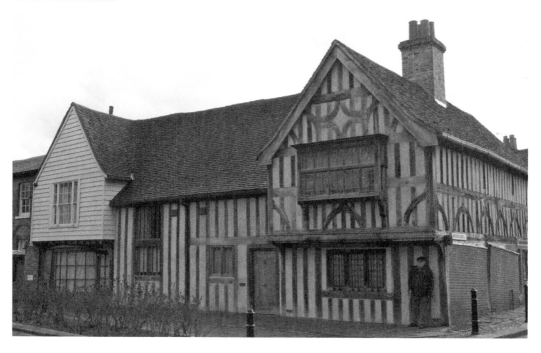

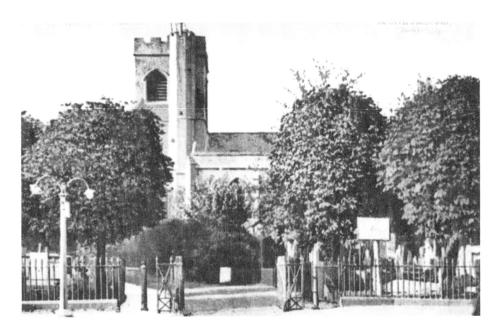

St Mary's Church

The first church on this site dates back to the twelfth century. Today it contains over 150 brasses and monuments. Over the thirteenth, fourteenth and fifteenth centuries, the church was altered. During the Second World War, the church also suffered bomb damage. Some of the metal railings within the churchyard were also removed then for the war effort. The churchyard contains graves from the First and Second World Wars, along with a number of famous people. Between 1995 and 2001, extensive restoration work was carried out on the church. Every year in June, a music festival is held by the church. St Mary's also holds a special place in the heart of the author, as it was the place where he got married to his wife, Annette, in 1973.

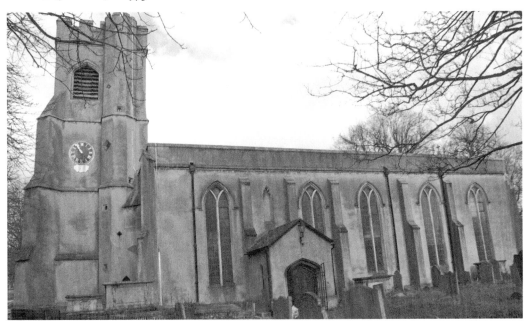

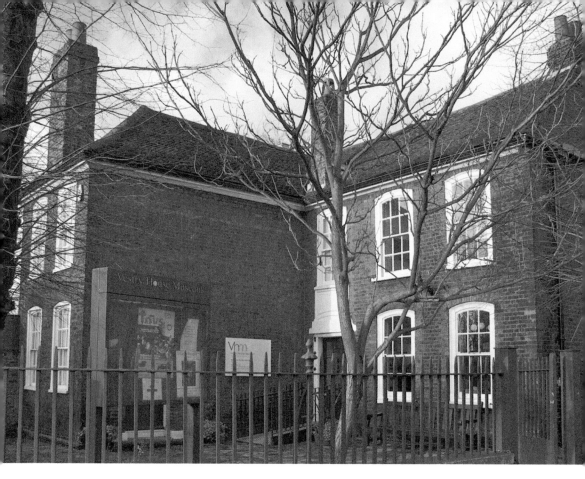

Vestry House Museum, Walthamstow Village
Built in 1730, the Vestry House Museum was originally a workhouse. After this it became a police station, and in 1931 the building was used as a local history museum. The museum is housed in a Grade II listed building, owned and operated by Waltham Forest Council. The museum was opened by Sir Ernest Pollock, Master of the Rolls, and today is also used as a local studies library and archive. One of the museum's many treasured objects is the first motor car to be built in Britain, constructed by Frederick Bremer in Walthamstow in 1892.

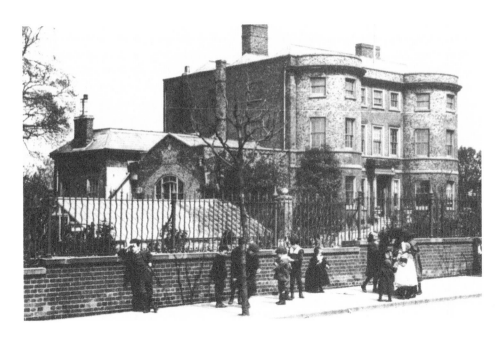

The Water House, Lloyds Park

The Water House, built in the 1760s, was one of many grand houses built in Walthamstow. Known today as the William Morris Gallery, it was also once known as The Winns, The Mansion, and the Water House. The picture below shows a Walthamstow tramcar and a horse-drawn cart outside the Water House in Forest Road. The world-famous writer, poet, designer and socialist William Morris lived in the house between 1848 and 1856. In 1857, the newspaper publisher Edward Lloyd bought the house and surrounding land and lived there until 1885. In 1898, Frank Lloyd, son of Edward Lloyd, offered the house and gardens to the Walthamstow Urban District Council to be used as a public pleasure ground. The story of the Water House and its gardens continues on the next page. Above is another image of the Water House, again viewed from Forest Road.

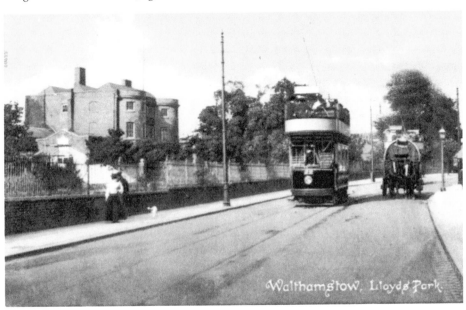

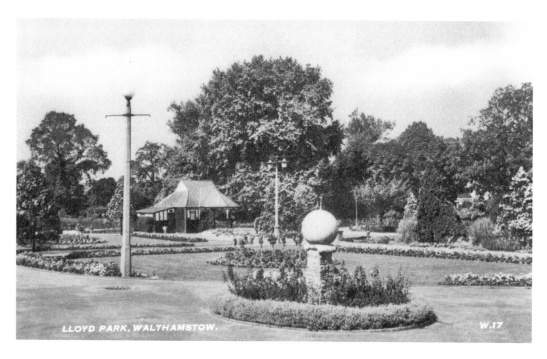

The William Morris Gallery and Lloyd Park

The gallery was opened by former Prime Minister Clement Attlee in 1950. It celebrates the life and legacy of William Morris, born in Walthamstow in 1834. In 2012, the Grade II* listed Georgian building and surrounding grounds (Lloyd Park) underwent major redevelopment. The gallery is owned and operated by Waltham Forest Council and was awarded the Art Fund Prize for Museum of the Year in 2013. A picture of the gallery today is shown below, with an image of the old gardens above.

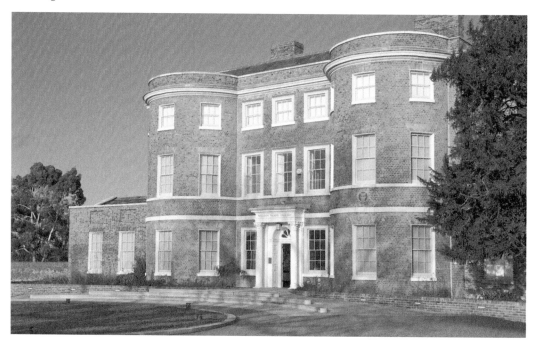

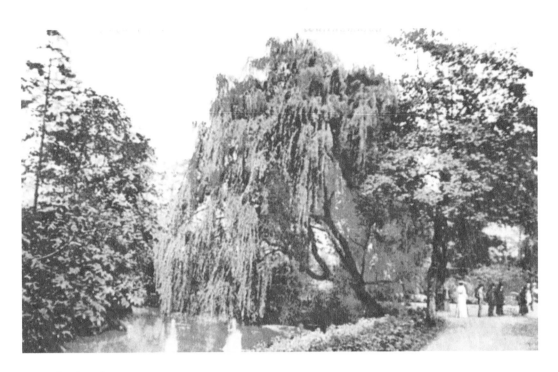

Lloyd Park

This park was named after the Lloyd family who once owned the Water House, its gardens and the park. It was opened by Sam Woods MP in 1900 and has been enjoyed by the public ever since. It was given to the Walthamstow Urban District Council by Frank Lloyd in 1898 and was transformed back to its former splendour in 2013 when the park and the Water House underwent major redevelopment, which sadly included the removal of the Lloyd Park Theatre. The images show a postcard shot taken by the lake, and a photograph of the park today.

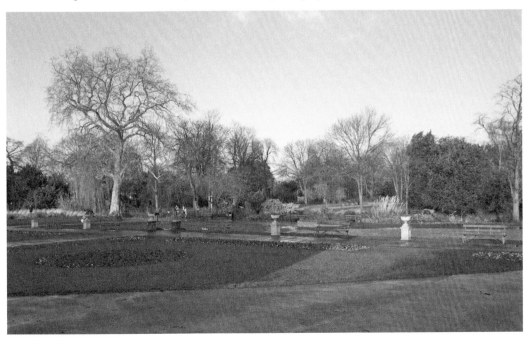

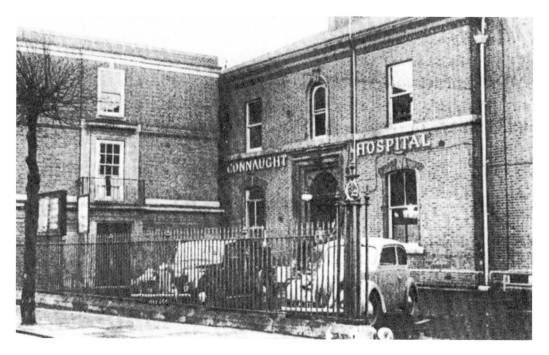

The Connaught Hospital

The Connaught Hospital was situated in Orford Road. Over the years the hospital operated on a number of different sites and under a number of different names over the years, until the Old Walthamstow Town Hall building was acquired in 1959. Although a proposal to enlarge it was considered, the hospital closed in 1977.

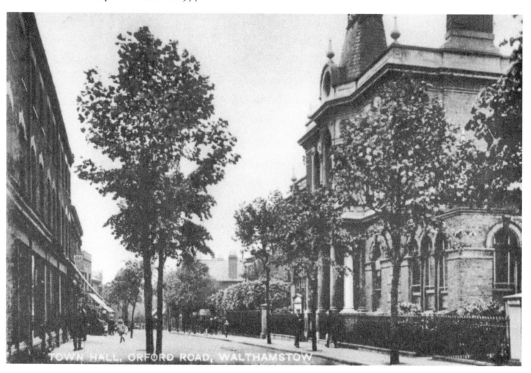

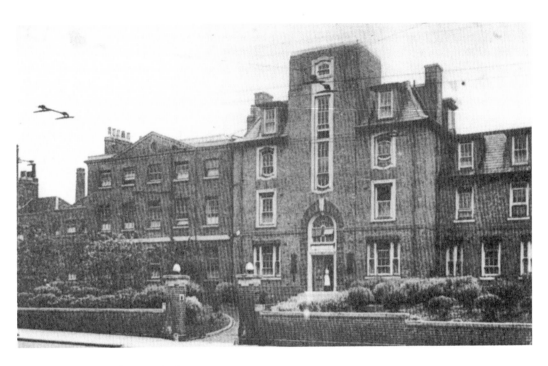

Thorpe Coombe Hospital

The hospital was opened as a maternity hospital in 1934 in part of a former mansion that was owned by Octavius Wigram. It ceased to be used as a maternity facility in 1973. It was then used as a nurse's home and a centre for people with Alzheimer's. Today, the hospital building is mainly used as a centre for people with mental health problems.

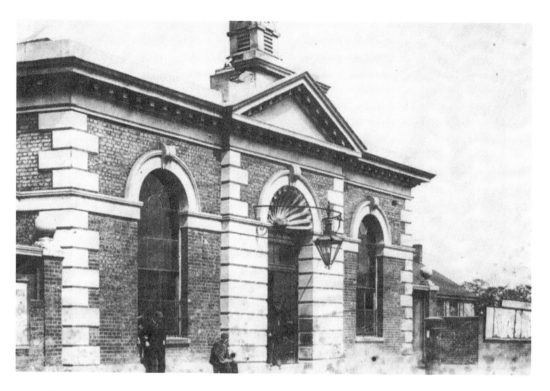

Lea Bridge Station

Lea Bridge station was built by the Northern & Eastern Railway in 1840. This beautifully proportioned station was styled differently from any other station on the line and contained a belfry, which housed a silver-plated bell. The bell would be rung to advise commuters of the impending arrival of a train, not only those on the platform but also in the wider community. The Northern & Eastern Railway opened from Stratford to Broxbourne in 1840, and later to Cambridge. By 1843 it claimed to be running the fastest trains in Britain on a track gauge of 5 feet. Robert Stephenson, the son of George Stephenson and famous for building the *Rocket*, was the engineer responsible for the railway's construction. It was closed by British Rail on 8 July 1985 and will be reopened shortly. Although the station today has an E10 Leyton postcode, it is regarded as the first station to serve the residents of Walthamstow.

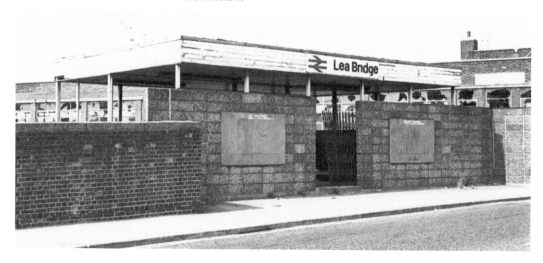

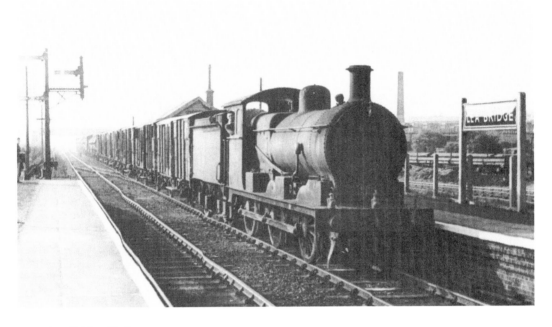

Lea Bridge Station

These two pictures show different periods during the station's operation. The picture above shows a freight train passing through the station with a rare view of the Lea Bridge station signal box at the end of the platform, and below is a picture of the last passenger service.

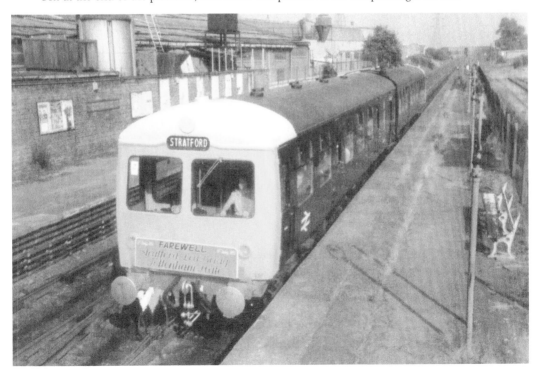

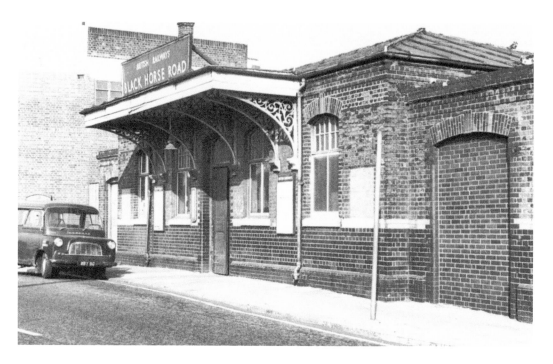

Black Horse Road Station

Black Horse Road station was opened on 19 July 1894 by the Tottenham & Forest Gate Railway. It was originally situated to the east of the current station. The station was resited in 1968 with new platforms next to the Victoria Line Underground station, which opened in the same year. The station now serves the Overground Line between Barking and Gospel Oak. The pictures show the old station building, which was sited on a bridge, and a view of the station's platform. The line's stations and signal boxes were all built in the same style.

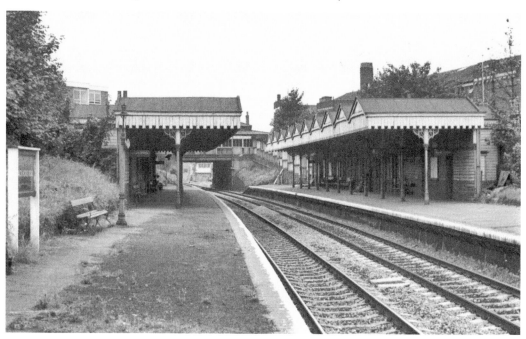

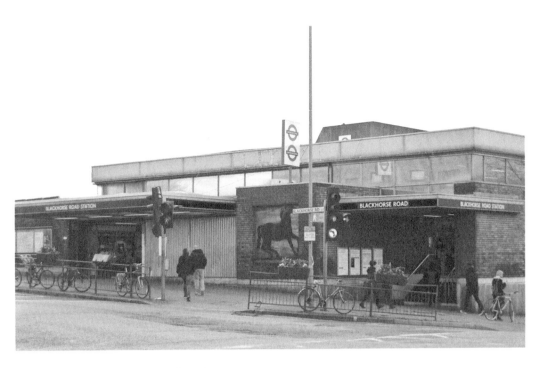

The New Blackhorse Road Station

Above is a picture showing the new Blackhorse Road station, which was opened in 1968. The station has a unique feature on the wall outside – a mural of a black horse. This is the only station on the Victoria Line that has such a feature. The station also has two new platforms for services for the Overground Line between Barking and Gospel Oak, shown below.

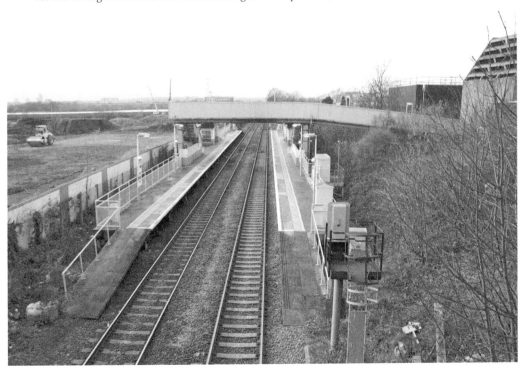

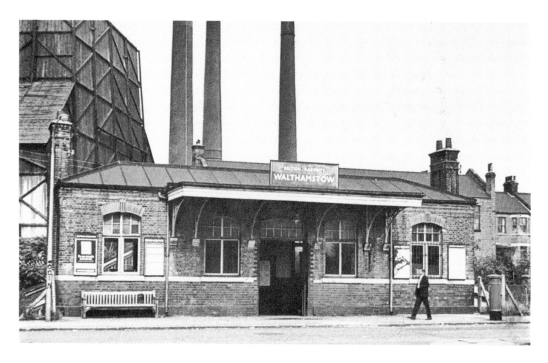

Walthamstow Station (Queens Road)

Today, this station is served by trains on the London Overground Line between Gospel Oak and Barking in East London. The station was opened as 'Walthamstow' on 9 July 1894 by the Tottenham & Forest Gate Railway and was changed to Walthamstow Queens Road in 1968. The station stands on Edinburgh Road, not Queens Road. The station is about 300 metres from Walthamstow Central station. A new footpath link to Walthamstow Central is currently under construction. The path was scheduled to be opened in 2013. It will be named Ray Dudley Way in commemoration of a local man and a good friend of the author who campaigned for this link to be installed for many years.

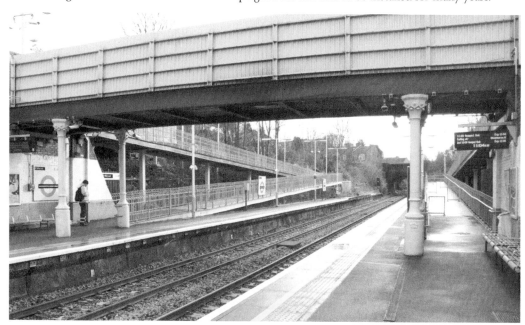

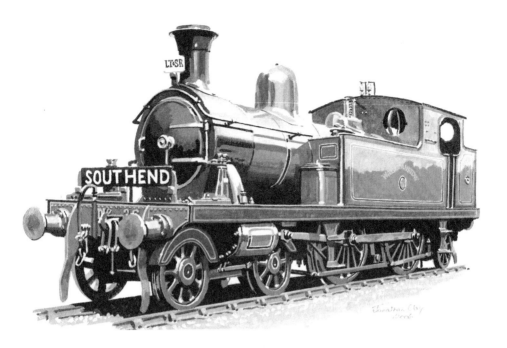

The Tottenham & Forest Gate Railway

The Tottenham & Forest Gate Railway was constructed in 1894 as a joint venture between the Midland Railway and the London, Tilbury & Southend Railway. Sir Courtenay Warner, a past mayor of Walthamstow and local property developer who owned large areas of land in Walthamstow, promoted the new line in order to serve his many newly built dwellings. Much of the line was constructed on the top of long, brick viaducts. Many existing properties were demolished to make way for it, which brought considerable local opposition to the railway. The line never had a coat of arms or even its own rolling stock in its early years of operation. Today, the line has become a very important cross-London route for freight and passenger service operations. Surprisingly, the line had to be saved from Dr Beeching's line closures of the 1960s. Many local residents today will remember those bank holiday day trips down the line to Westcliff, Southend-on-Sea, or even Shoeburyness. The two images shows a painting by Jonathan Clay, commissioned by the author, of a LTSR tank engine named *Walthamstow*, and an image of a station totem (or 'hotdog', as it was also known). In British Railway days, all stations had these on their platforms.

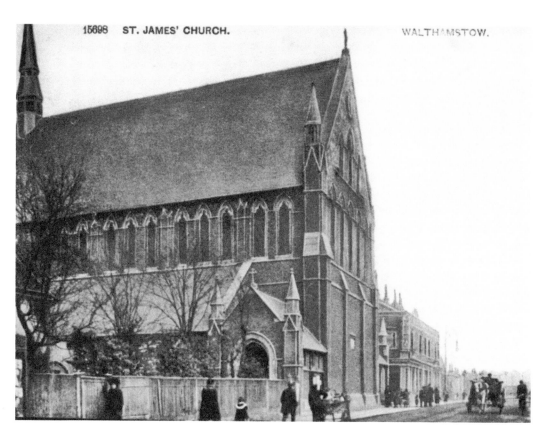

St James' Church

Opposite the site of the old Colliers Brewery in St James Street, you would have once found the splendid church of St James. The church was built in 1842 on a site given by the vicar of St Mary's and S. R. Bosanquet. It was demolished and rebuilt in 1902/03. The new building was designed by J. E. K. & J. P. Cutts and contained the altar, east window, and many of the bricks from the old 1842 church. It was closed in 1960 and demolished in 1962. Today you will find the St James Health Centre on the site of the old church.

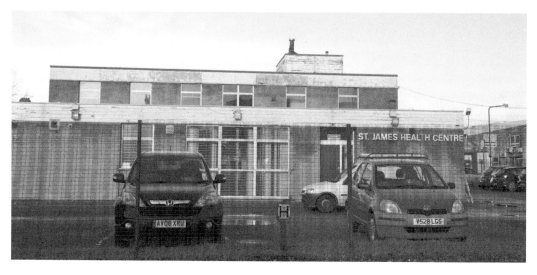

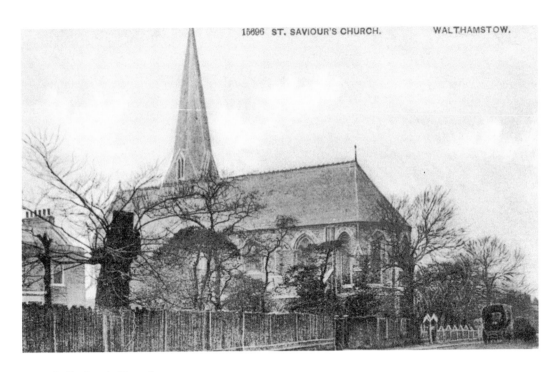

St Saviour's Church

The St Saviour's church in Markhouse Road was built in 1874. It was designed by T. F. Dolman. It became the parish church of St James and today is the only church in Walthamstow from the days of the Gothic Revival. Built of stone in a correct thirteenth-century style, it consists of an aisled nave, apsidal chancel, and tall north-west tower with broach spire. The pictures are a postcard view of the church and a photograph of the church as it is today.

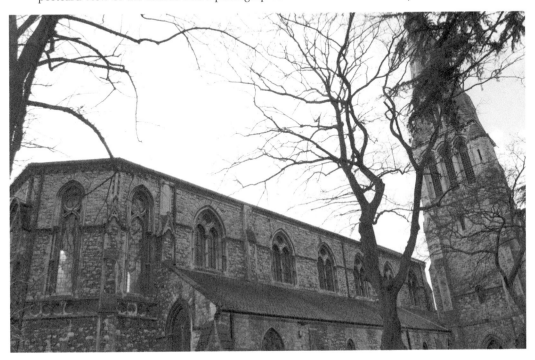

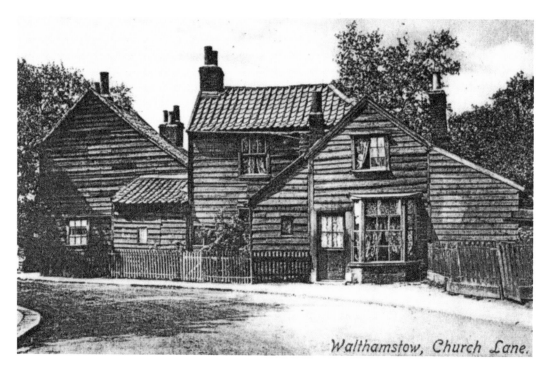

Walthamstow, Church Lane.

Pictures of Old Walthamstow

Here are two pictures from old Walthamstow, one of a timber building on Church Lane and the other of the old Monoux Almshouses, taken around 1906. While the Church Lane building has long since vanished, the Monoux Almhouses still provides accommodation to Walthamstow's older citizens to this day.

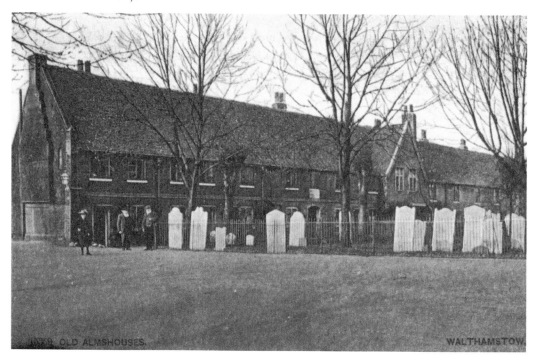

OLD ALMSHOUSES. WALTHAMSTOW.

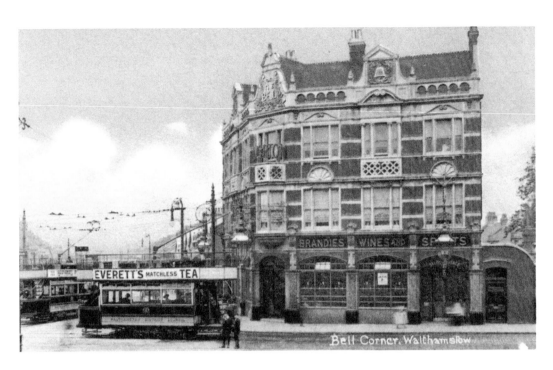

The Bell Public House

The postcard above shows a Walthamstow Urban District Corporation tramcar outside the pub in the early 1900s. Extensive refurbishment was carried out on the pub in 2013 and it is a very popular drinking venue once again, as seen in the photograph below.

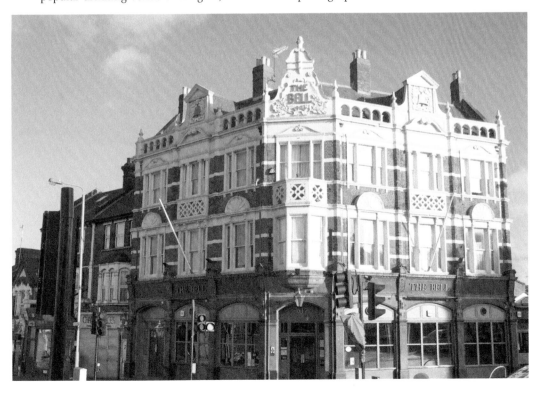

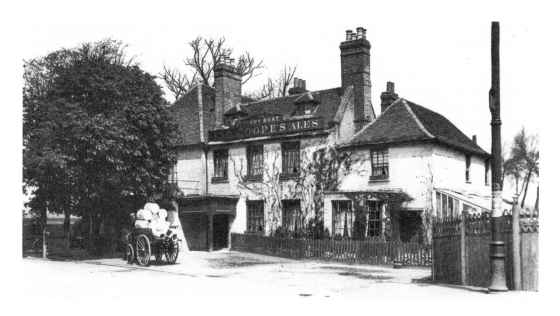

The Ferry Boat Inn and River Crossings

The most important river crossing through the Middle Ages was a crossing of the River Lea and the River Fleet on the borders of Walthamstow with Tottenham. Ralph de Tony was required to build two bridges next to the site of the inn where several 'holms' or islets were then situated. These two bridges were built in 1277. A ferry beside the bridge was also mentioned as being there in 1722. In 1738, the old ferry house then became the Ferry Boat Inn, and in 1760 the old bridge crossing the River Lea was rebuilt by Sir William Maynard as a private toll-bridge for horses and carriages. The bridge was constructed out of timber but had cast-iron abutments. It is also stated that a local person about this time claimed the rights to cross the river without the payment of any toll. In 1820, the bridge was repaired by Viscount Maynard and, in 1868, the East London Waterworks Company bought the inn and the tolls. In 1877, the bridge was freed of tolls after the Corporation of London bought all the rights. The old bridge was demolished in 1915 when the present Ferry Lane Bridge was built. A new bridge over the River Fleet in Ferry Lane was constructed by the district council in 1904.

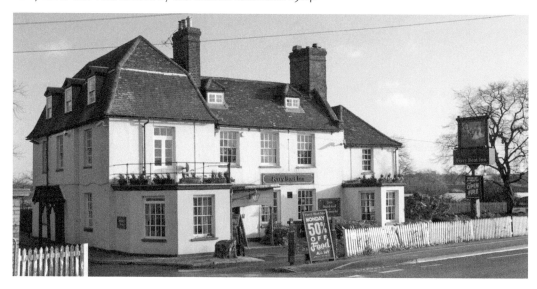

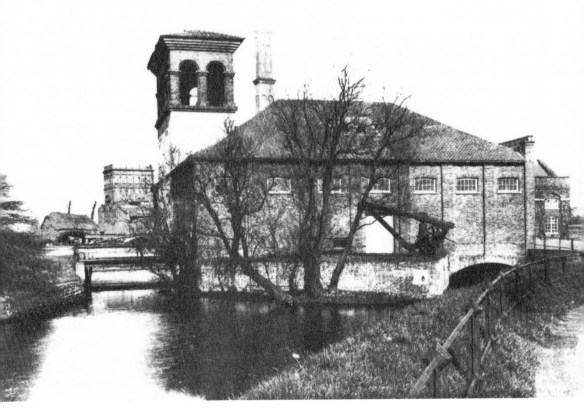

The Walthamstow Copper Mill

It has been stated in the Domesday Book that Walthamstow has always had a mill, and that a mill of some kind has been situated on the current mill site since the fourteenth century. It was firstly used for grinding corn and then for making gunpowder in the 1670s. In the 1690s, it was used for the rolling of paper. The mill was powered by water from the River Lea. In 1712, it became a leather mill and, in 1743, linseed oil was being manufactured there. In 1808, the mill was purchased by the British Copper Company and was then used to produce copper penny and halfpenny tokens. The bottom end of Walthamstow High Street, or Marsh Street as it was also known, was renamed Coppermill Lane to commemorate the existence of the mill. The mill was taken over by William Foster & Company, which continued to produce tokens until 1857. It should be noted at this stage that the mill was an important employer of local people. The mill was then purchased by the East London Waterworks Company, with the mill's waterwheels being used to power water pumps for the construction of the company's reservoirs. The tower at the back of the mill shown in the picture was added in 1864, and was thought to have been built to house a steam engine. Today the mill is owned by Thames Water and is used as a store.

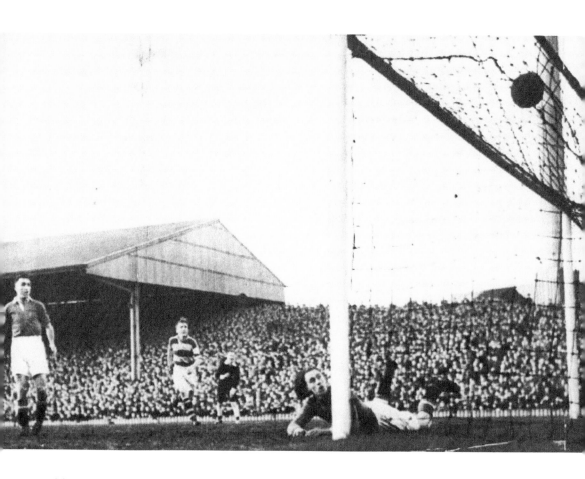

Walthamstow Avenue Football Club

Walthamstow Avenue Football Club was founded in 1900, and played at a ground in Green Pond Road. Dressed in dark and light-blue shirts with light-blue shorts, the amateur club was extremely successful during the 1950s. In 1988, the club was absorbed into Leytonstone/Ilford, later renamed Redbridge Forest. They are known today as Dagenham & Redbridge. The picture shows Jim Lewis scoring a goal at Old Trafford against Manchester United in the fourth round of the FA Cup, which finished 1-1. The reply was at Highbury, which Manchester United won 5-2.

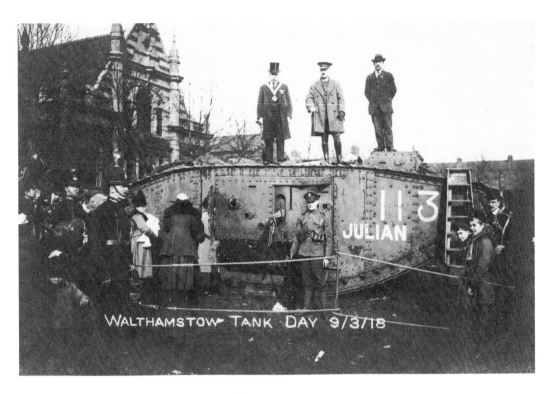

WALTHAMSTOW TANK DAY 9/3/18

Walthamstow During the First World War

The picture above is of a tank day held in the gardens at Selborne Walk in 1918, and below is a picture of a group of unknown soldiers, one of whom is believed to be a relative of the author's wife.

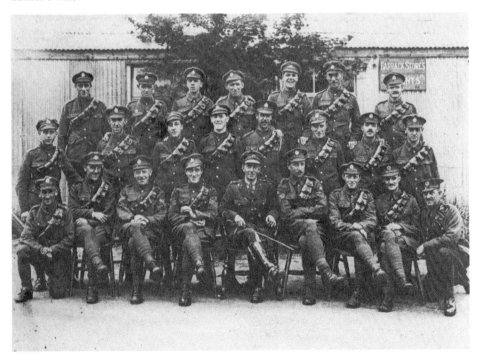

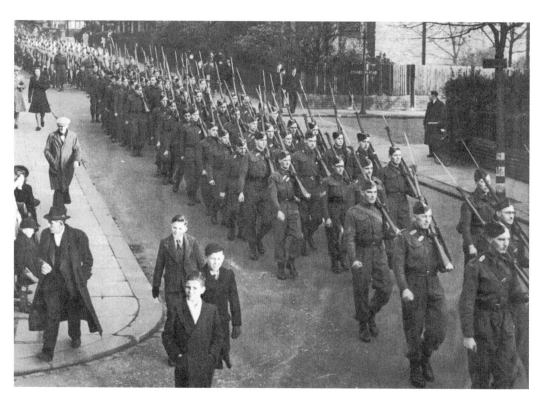

Walthamstow During the Second World War

The picture above shows a number of soldiers marching through the streets of Walthamstow, and below is a photograph of group of Royal Air Force personnel, which includes the author's wife's late father, standing in front of an Avro Anson aircraft.

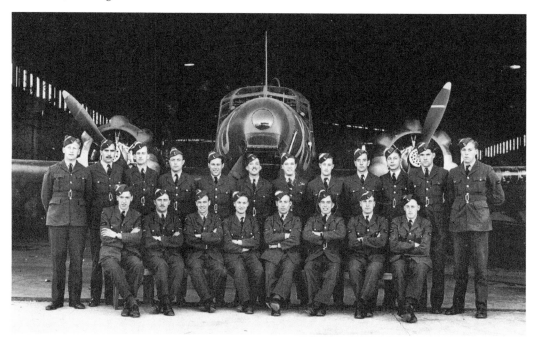

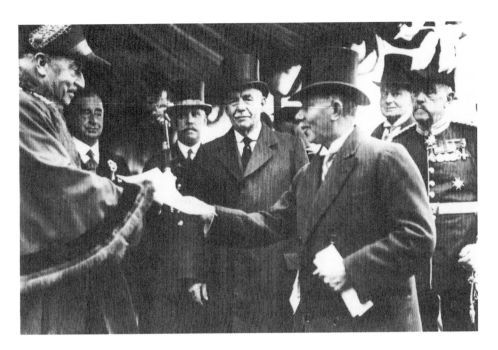

The Warner Story

We have already touched on the history of the Warner family and their influence in the development of the borough's railways, politics, and house building. These two pictures show Sir Courtenay Warner receiving the Borough Charter (*above*), and a Warner company house built in 1925, with the WE logo (Warner Estates) on the building (*below*).

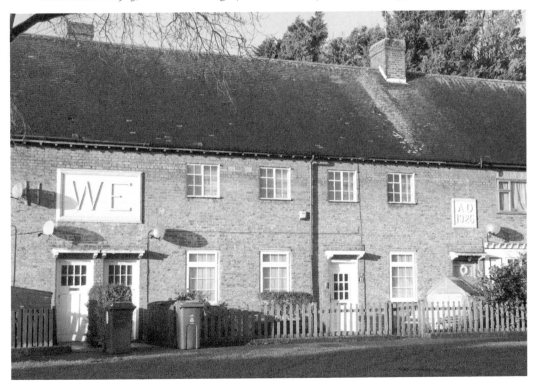

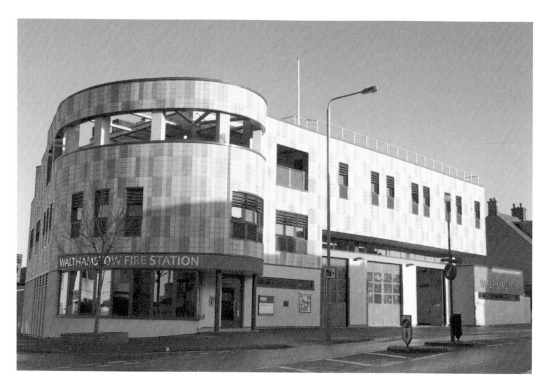

The New Walthamstow Fire Station & Old Police Station

The new £7.5 million fire station in the top picture was opened in 2012. It replaced the old fire station that was built on the same site in the 1920s. It was one of a number of fire stations to be constructed in Walthamstow over the years. Below, the old police station, also on Forest Road, was closed in 2011 and put up for sale.

Acknowledgements

I would firstly like to thank my wife, Annette, and the rest of my family for supporting me in my historical endeavours for the past twenty years. I would also like to thank all my friends and the volunteers at the Walthamstow Pumphouse Museum for their continued support over the years. Thanks also go to my good friend Dr Jim Lewis, who has inspired me to continue with my work in celebrating Britain's important industrial past, and to the team at Amberley Publishing for all their help in the production of this publication.

In closing, I must thank my late mother and father for all the support they gave me during their lifetime. Without them, I would most certainly not have been in the position to produce this publication. I would therefore like to dedicate this book to them.

Image Sources

About the Author

Born in Australia in 1950, Lindsay Collier returned to Britain as a baby with his parents, who had emigrated there after the Second World War. After leaving school aged sixteen, he has had many jobs over the years, spending a number of years as an employee of the Australian High Commission in the Strand. During this time, he travelled around the world with his wife, Annette, who he married in Walthamstow at St Mary's church in 1973. After moving to Walthamstow some forty years ago, Lindsay has worked for a local freight forwarding company, as a licenced black cab driver – like his father – and even as a part-time DJ. During his time as a cab driver, he was able to spend more time with his two young children, Julie and Mark, and ran a local junior football team for his son.

Around this time, he joined a local model railway club (of which he would later become secretary) at Low Hall Depot in the Low Hall pump house, which triggered his interest in industrial heritage and the pump house itself. When his son started taking an interest in music and started up his own boy band, Lindsay, having some past knowledge of the music industry, agreed to be their manager. By this time, his museum project was also underway, so he had to split his spare time between working on this and the boy band. However, the group subsequently disbanded and Lindsay was free to dedicate more of his time to the museum project.

On the recommendation of the museum directors, he began to study for a Master of Arts degree in Museum and Gallery Management at the City of London University, which he obtained in 2004. Today, Lindsay still drives his cab around London when he can. He now has two granddaughters, and his other baby, the Walthamstow Pumphouse Museum, is still moving forward. In his spare time, he keeps busy with his Masonic interests, and is also a local radio host and writer. In 2013, Lindsay was awarded the Freedom of the City of London at the Guildhall.